Remembering Little Rock

Kimberly Reynolds Rush

T U R N E R

PUBLISHING COMPANY

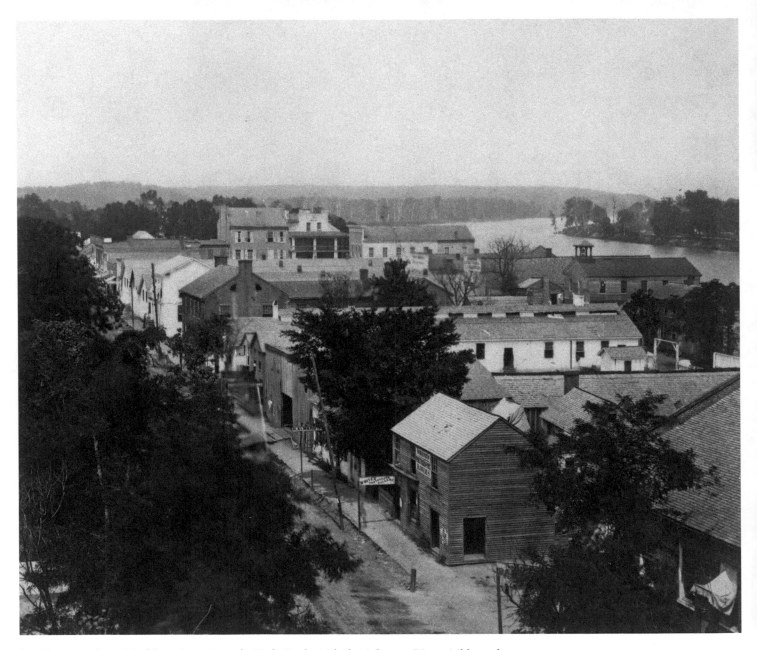

Looking west down Markham Street in early Little Rock, with the Arkansas River visible to the immediate north.

Remembering Little Rock

Turner Publishing Company
www.turnerpublishing.com

Remembering Little Rock

Copyright © 2010 Turner Publishing Company

Library of Congress Control Number: 2010932641

ISBN: 978-1-59652-715-7

Printed in the United States of America

ISBN 978-1-68336-849-6 (pbk.)

CONTENTS

ACKNOWLEDGMENTS.. VII

PREFACE ... VIII

AN ENTERPRISING SPIRIT
(1860s–1899).. 1

STRICTLY MODERN
(1900–1919) ...25

COLLISIONS
(1920–1939) ...71

CRISIS AND REDEMPTION
(1940–1960s) ..91

NOTES ON THE PHOTOGRAPHS ...132

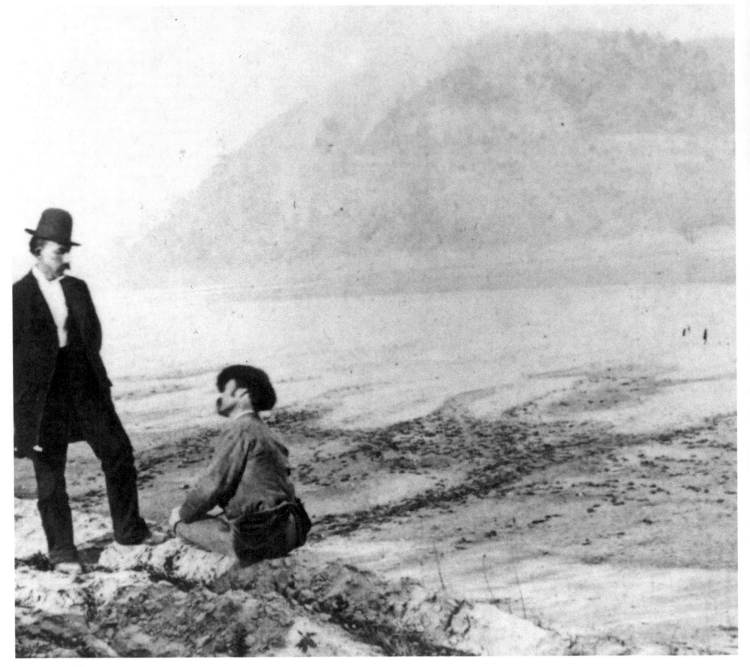

A view of Big Rock Mountain, opposite Little Rock, from around the 1870s.

ACKNOWLEDGMENTS

This volume, *Remembering Little Rock,* is the result of the cooperation and efforts of many individuals and organizations. It is with great thanks that we acknowledge the valuable contribution of the following for their generous support:

Arkansas History Commission
Butler Center for Arkansas Studies, a department of the Central Arkansas Library System
The Library of Congress
University of Arkansas at Little Rock

———————

The writer would like to thank Ryan Rush and Sandy Reynolds for their invaluable assistance in proofreading the text and Kati Bazzell for taking the writer's photograph.

PREFACE

Little Rock has thousands of historic photographs that reside in archives, both locally and nationally. This book began with the observation that, while those photographs are of great interest to many, they are not easily accessible. During a time when Little Rock is looking ahead and evaluating its future course, many people are asking, How do we treat the past? These decisions affect every aspect of the city—architecture, public spaces, commerce, infrastructure—and these, in turn, affect the way that people live their lives. This book seeks to provide easy access to a valuable, objective look into the history of Little Rock.

Although the photographer can make decisions regarding subject matter and how to capture and present it, photographs, unlike words, are less prone to interpret history subjectively. This lends them an authority that textual histories sometimes fail to achieve, and offers the viewer an original, untainted perspective from which to draw his own conclusions, interpretations, and insights.

This project represents countless hours of review and research. The researchers and writer have reviewed hundreds of photographs in numerous archives. We greatly appreciate the generous assistance of the individuals and organizations listed in the acknowledgments of this work, without whom this project could not have been completed.

The goal in publishing this work is to provide broader access to this set of extraordinary photographs that seek to inspire, provide perspective, and evoke insight that might assist people who are responsible for determining Little Rock's future. In addition, the book seeks to preserve the past with adequate respect and reverence.

With the exception of touching up imperfections that have accrued with the passage of time and cropping where necessary, no changes have been made. The focus and clarity of many images is limited by the technology and the ability of the photographer at the time they were taken.

The work is divided into eras. Beginning with some of the earliest known photographs of the city, the first section records photographs through the end of the nineteenth century. The second section spans the beginning of the twentieth century through World War I. Section Three moves from the 1920s through the 1930s, and the last section covers the World War II era to recent times.

In each of these sections we have made an effort to capture various aspects of life through our selection of photographs. People, commerce, transportation, infrastructure, religious institutions, and educational institutions have been included to provide a broad perspective.

We encourage readers to reflect as they go walking in Little Rock, strolling through the city, its parks, and its neighborhoods. It is the publisher's hope that in utilizing this work, longtime residents will learn something new and that new residents will gain a perspective on where Little Rock has been, so that each can contribute to its future.

—Todd Bottorff, Publisher

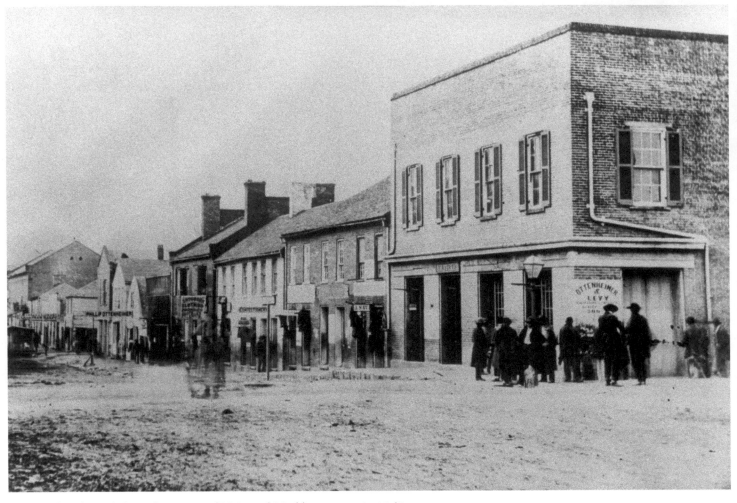

A view of Little Rock from the corner of Main and Markham streets in 1863.

An Enterprising Spirit

(1860–1899)

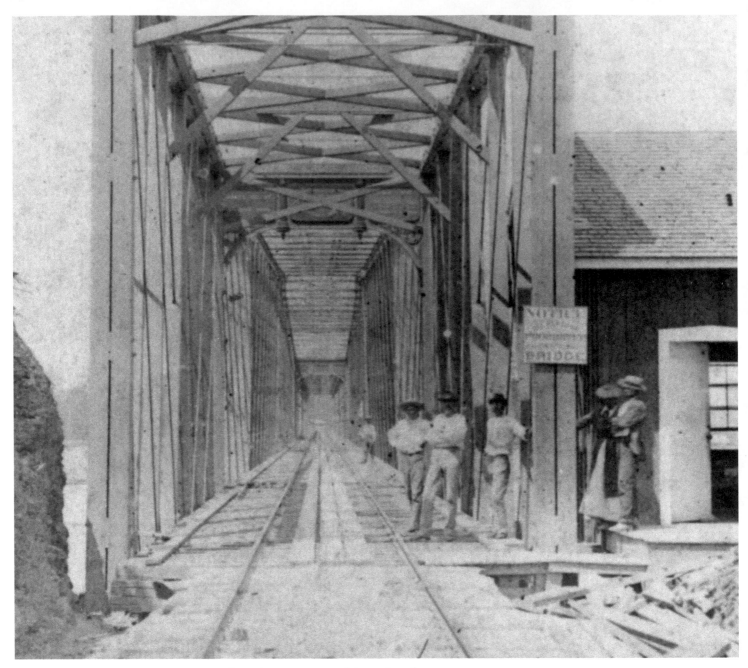

A railway bridge over the Arkansas River from the perspective of those aboard a train.

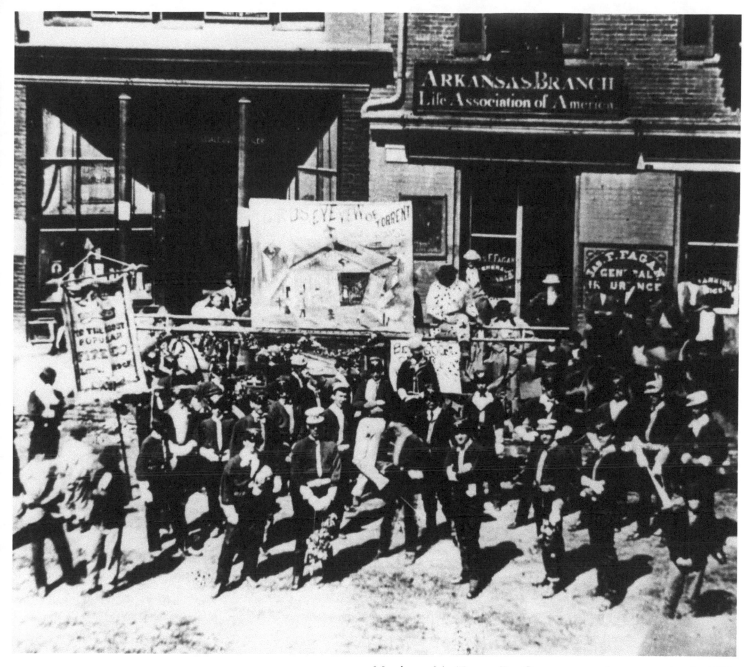

Members of the Torrent Fire Company pose for a group shot in 1872.

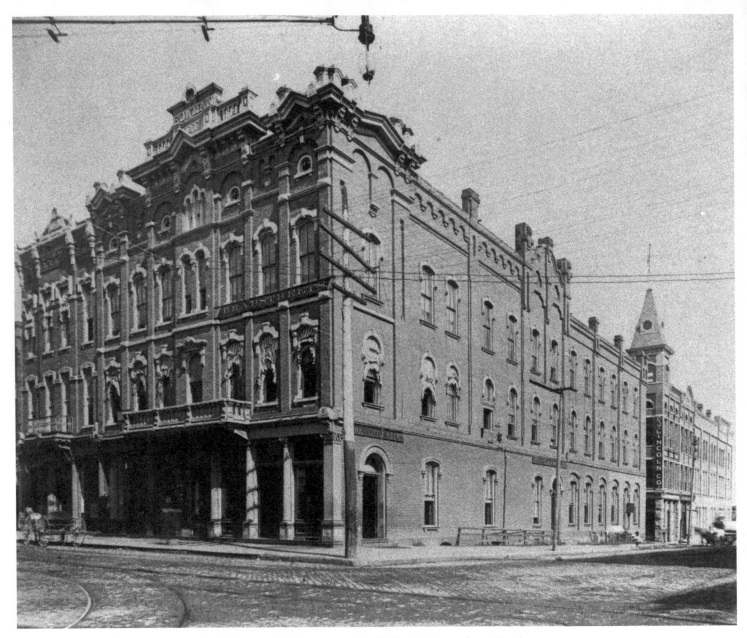

The Bowman block, at the corner of Markham and Main streets. The ill-fated Metropolitan Hotel
would open in this building.

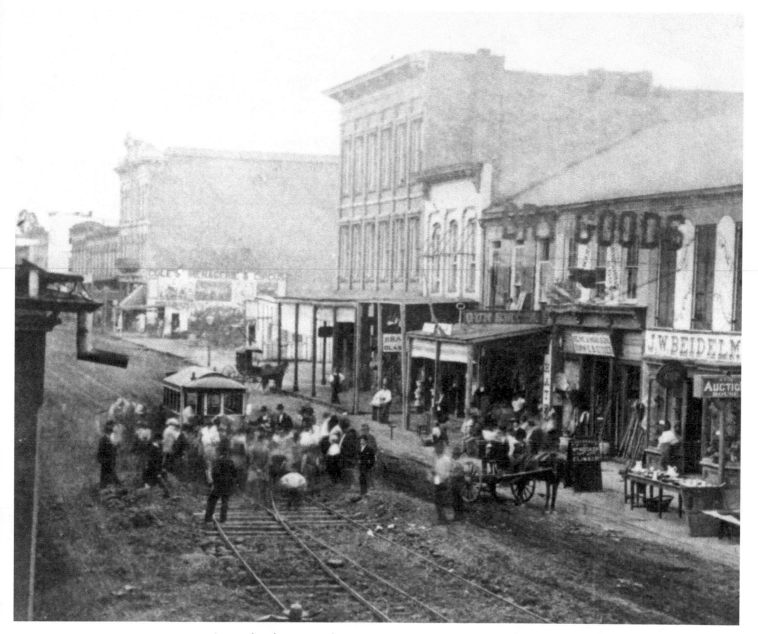

A crowd gathers around a streetcar on Main Street during the inauguration of the city's mule-powered railway in May 1877. By 1891, an electric streetcar system would be up and running. Streetcars were the main form of public transportation in Little Rock until 1947, when they were replaced with bus service.

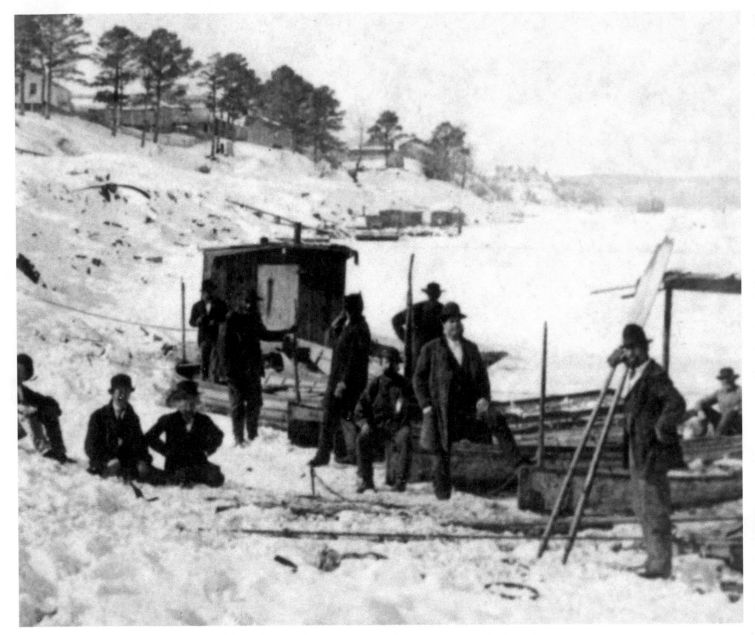

A group of men gathers on the banks of the Arkansas River during the winter of 1876. A blanket of snow carpets the riverbank and the river, which had frozen.

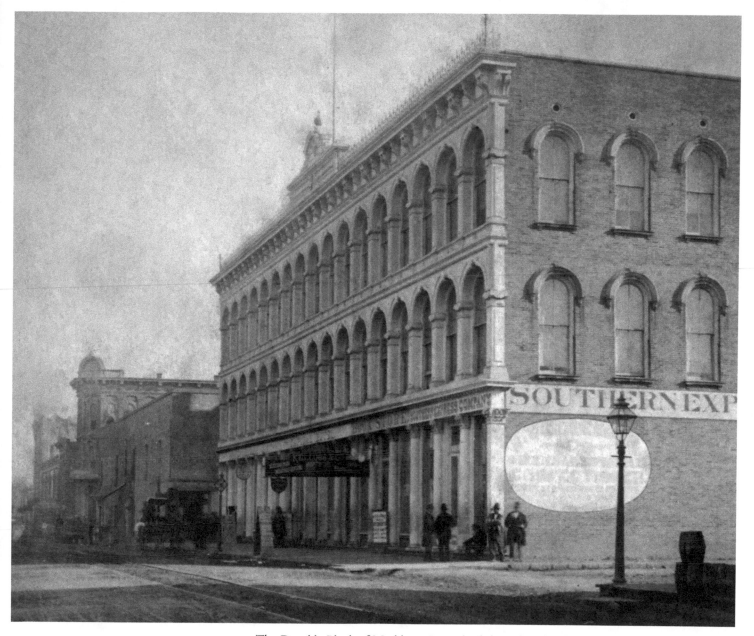

The Denckla Block of Markham Street, built by railroad magnate William Denckla to house downtown businesses, would be refitted in 1877 to become the grand Capital Hotel. In the nineteenth century, "block" was commonly used to denote a building.

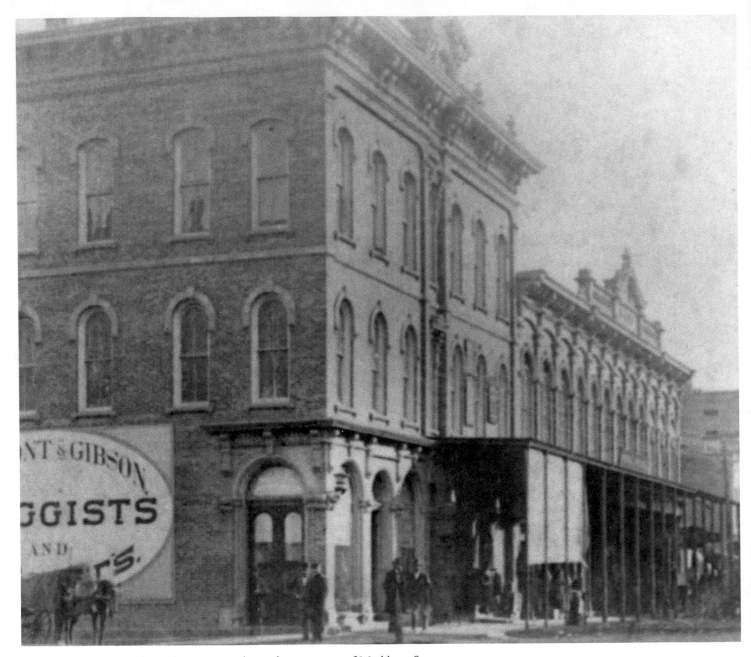

The McAlmont and Gibson drugstore was located on a corner of Markham Street.

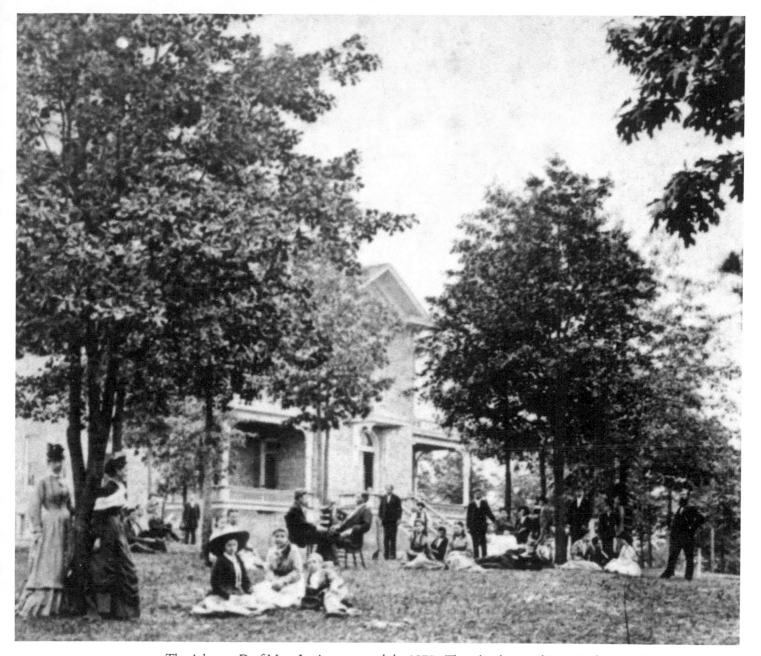

The Arkansas Deaf Mute Institute, around the 1870s. The school opened in 1870, but was destroyed by fire in 1889. A new building was built in the same location and today houses the Arkansas School for the Deaf.

A group of men pose for a photograph around the 1870s. Behind them rises the steeple of the local Catholic church.

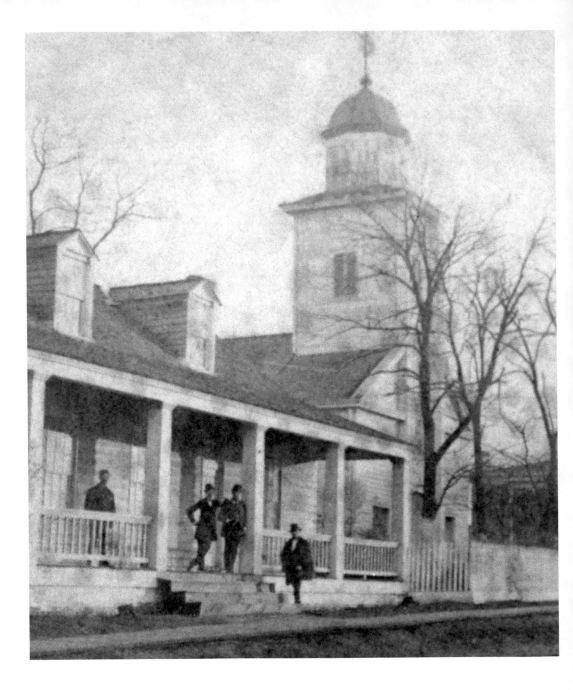

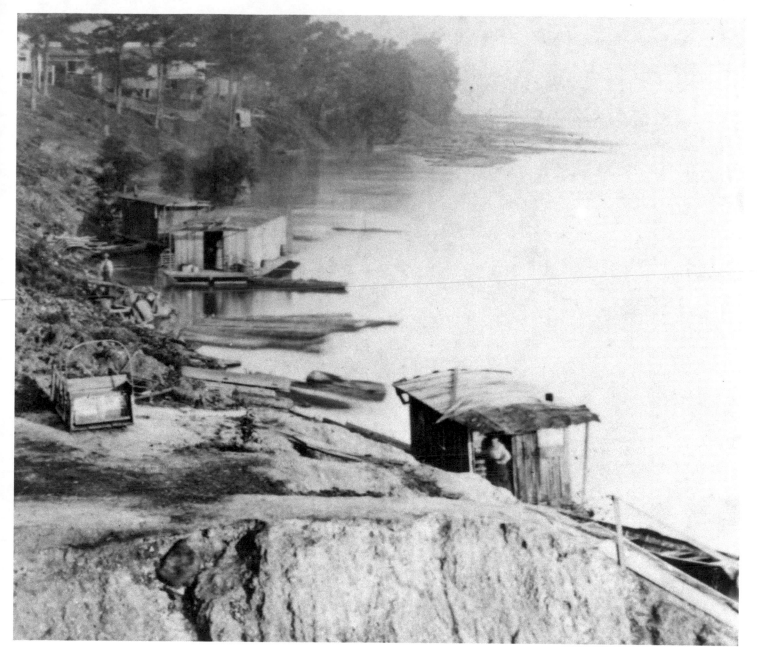

An early-day view of life on the banks of the Arkansas River.

Piney Point on a frozen Arkansas
River during the winter of 1880.

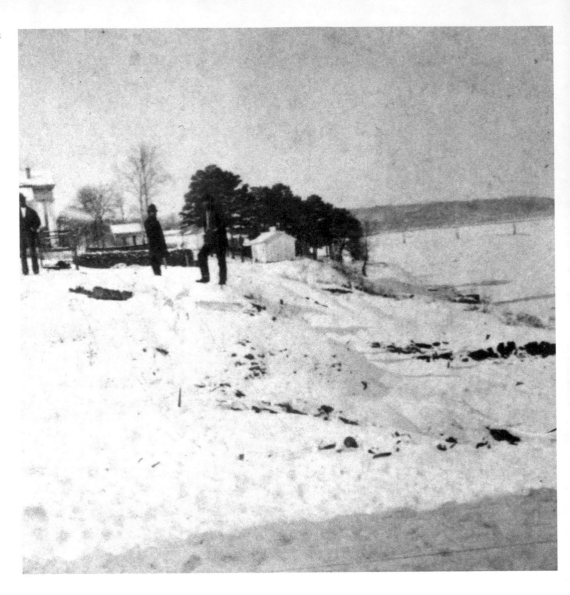

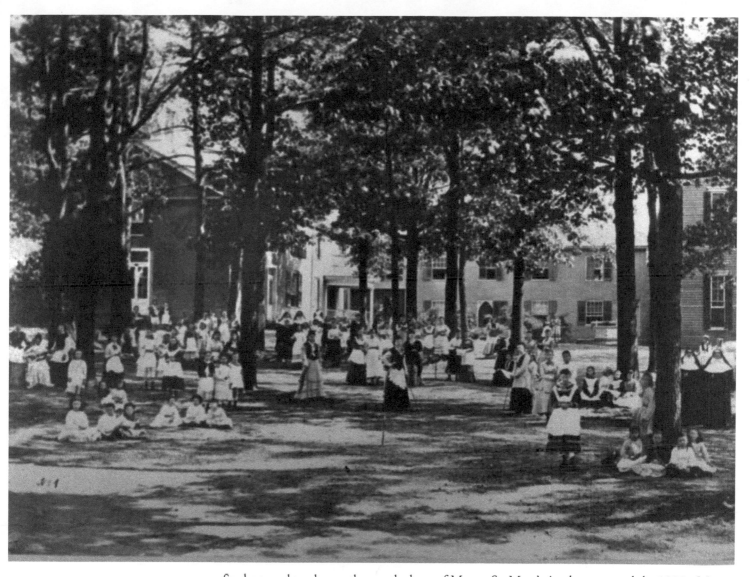

Students and teachers gather on the lawn of Mount St. Mary's Academy around the 1880s. Mount St. Mary's, a Catholic school established in 1851, is the oldest education institution in the state. The school later moved to its current location in Pulaski Heights and today is the only all-girl secondary school in Arkansas.

The Milton Rice House on Twentieth Street, around the 1880s. Milton Rice was a state senator, a lawyer, and the president of the Cairo and Fulton Railroad. In 1870, he built this Gothic revival house and named it Oak Grove. Today the Milton Rice House can be found at 2015 South Battery Street.

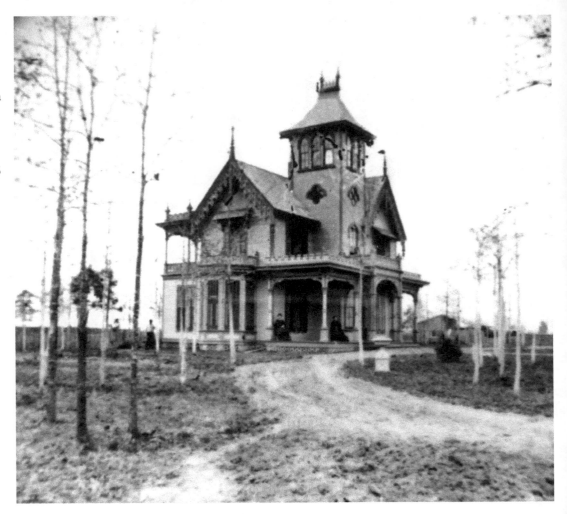

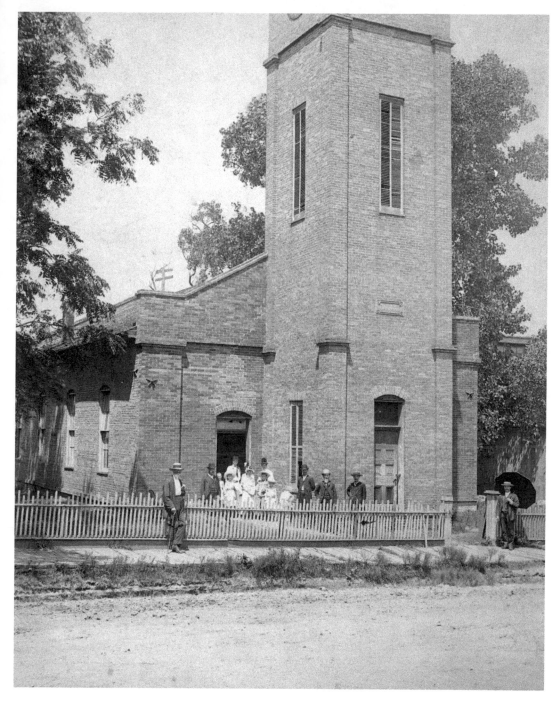

The First Christian Church was located between Third and Fourth streets. These church members are posing for a photograph in front of the building around 1885.

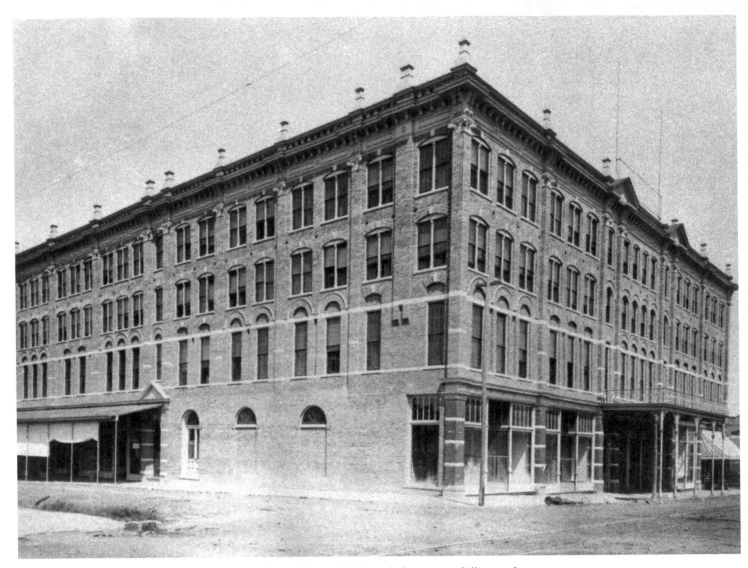

The Hotel Richelieu. In October 1894, a tornado would rumble through downtown, killing and maiming citizens and badly damaging the hotel and most other buildings in the business district, including the Western Union telegraph office and the quarters of Governor Fishback.

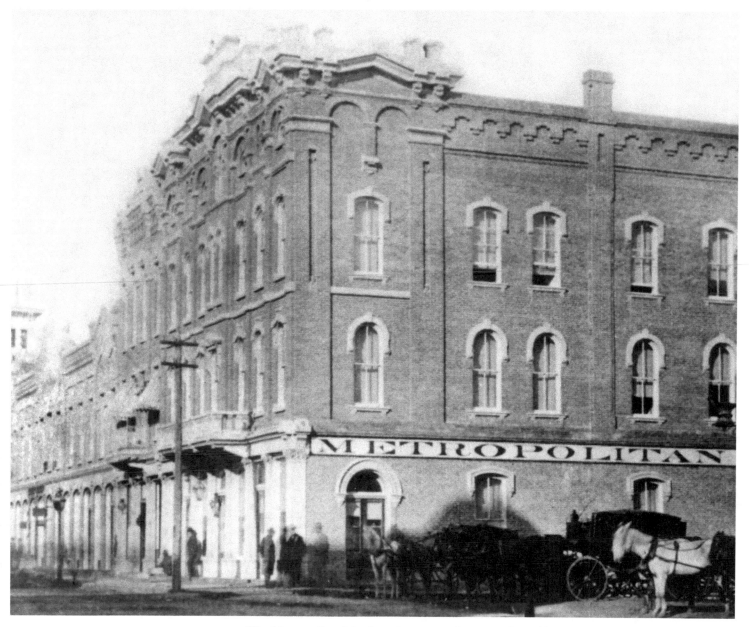

The Metropolitan Hotel on the corner of Main and Markham streets, around the early 1870s. The city's only upscale hotel of the day, it was destroyed by a fire on December 14, 1876. The loss prompted construction of the grand Capital Hotel, a city landmark to this day.

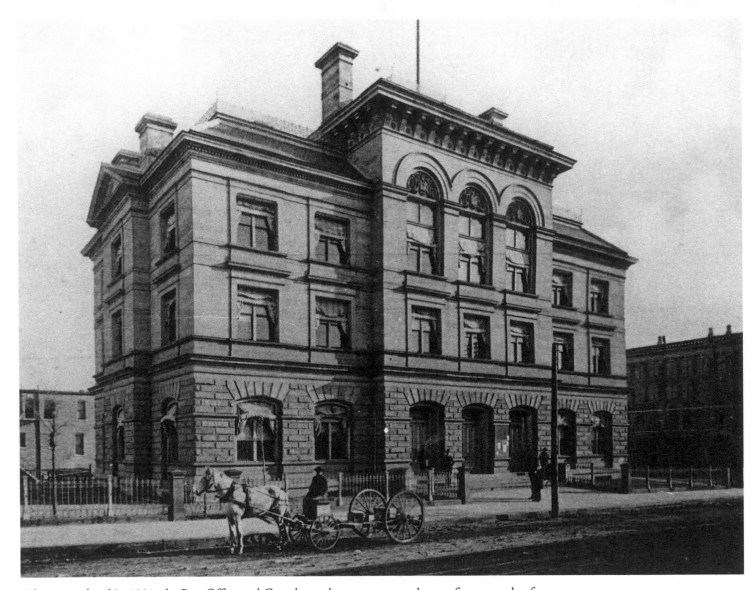

When completed in 1881, the Post Office and Courthouse became noteworthy as a fine example of Victorian-era Italian Renaissance Revival architecture. Located on West 2nd Street, the building has been carefully restored.

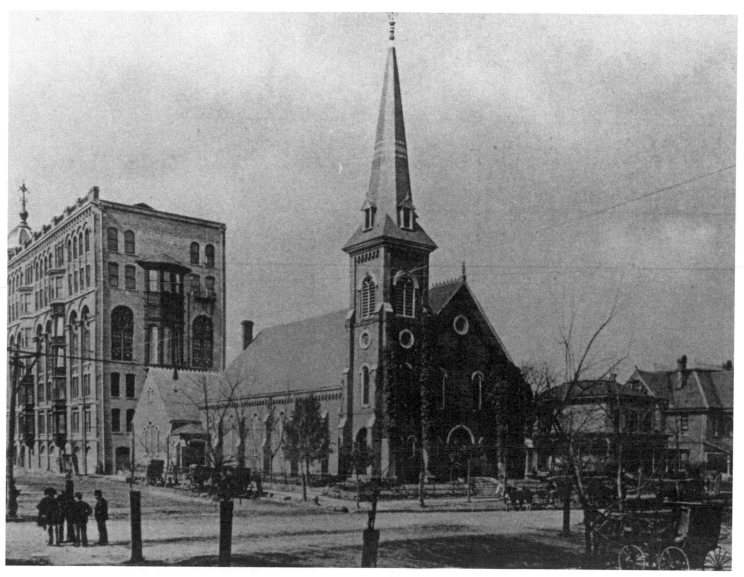

The Masonic Temple Building, located at Fifth and Main streets, in 1892. The building was completed in 1891 to become the largest commercial building in the city. It was destroyed by fire in 1919.

The First German Evangelical Lutheran Church, located at Eighth and Rock streets. Home today to the First Lutheran Church, the building remains standing.

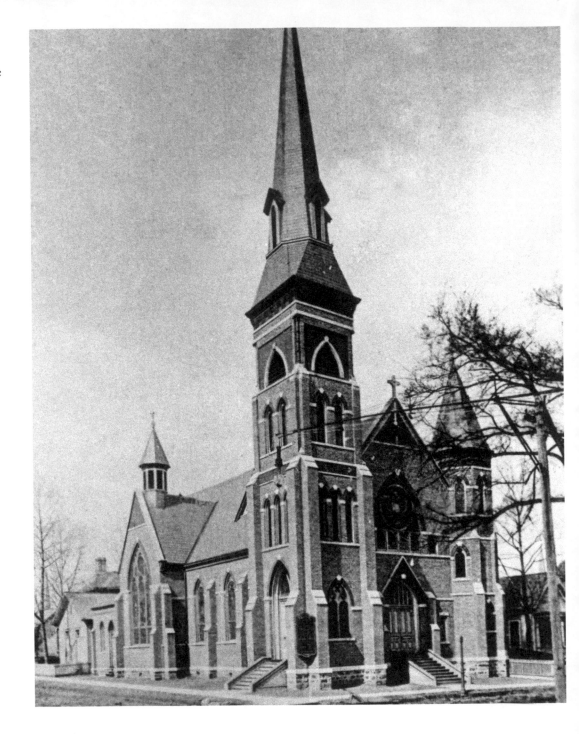

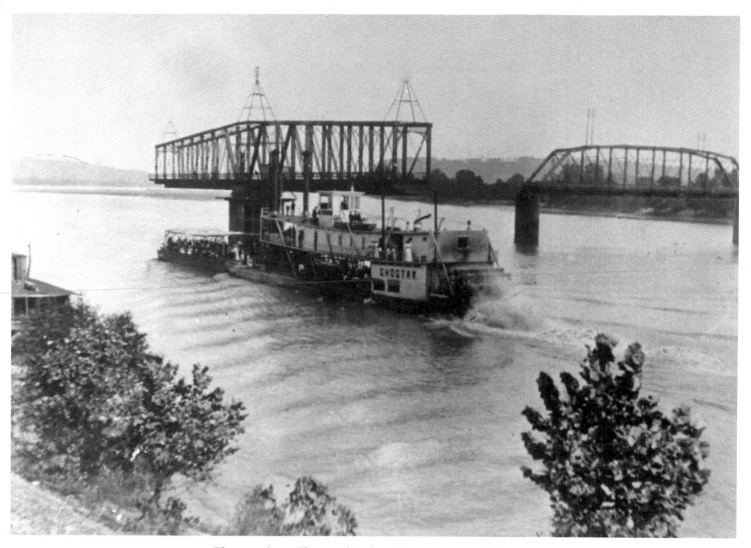

The steamboat *Choctaw* plies the Arkansas River in 1894, passing the first Baring Cross Bridge. Built in 1873, the Baring Cross was the first bridge to span the river at Little Rock. The bridge washed away in the floods of April 1927, but was soon rebuilt by the Missouri Pacific Railroad, reopening in 1929.

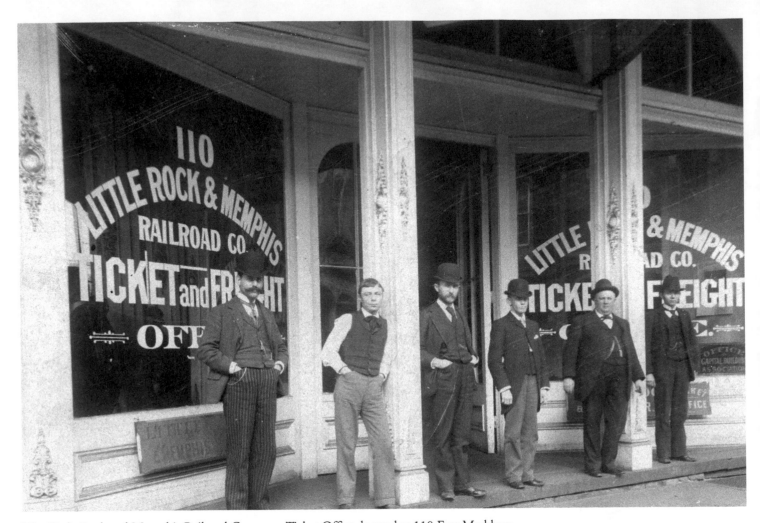

The Little Rock and Memphis Railroad Company Ticket Office, located at 110 East Markham, around 1895.

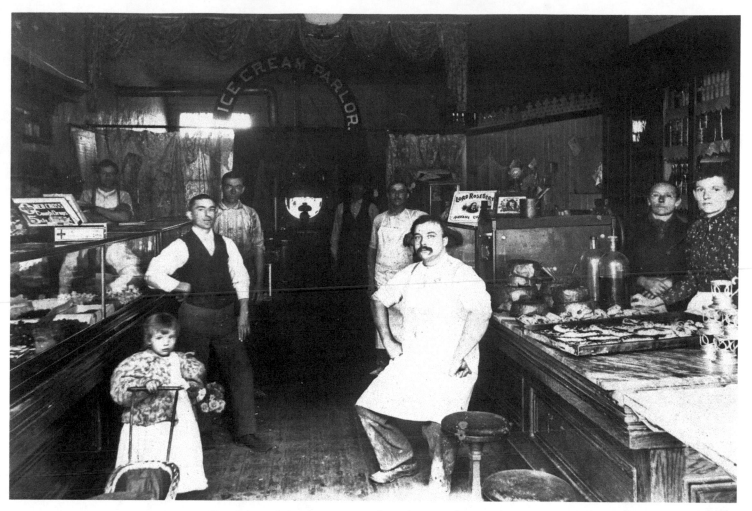

Shoppers and shopkeepers pose for a photograph around 1895 inside B. Heine Confectionery, at 718 Main Street.

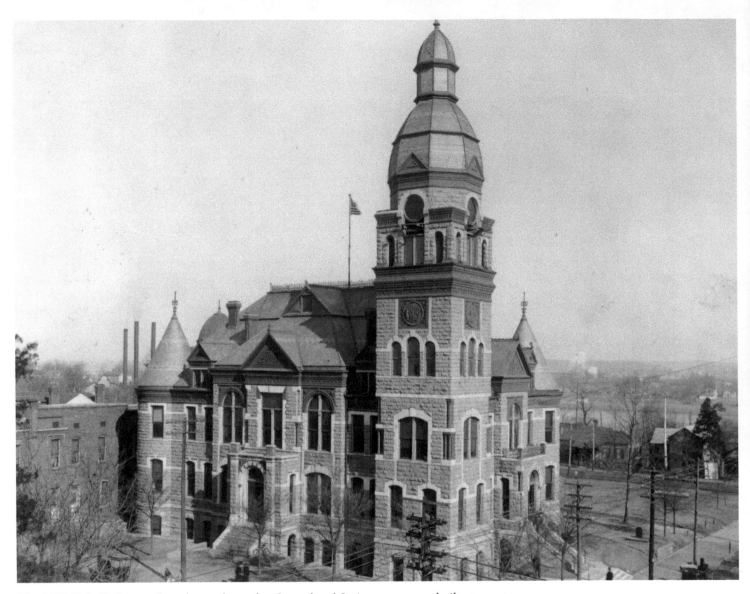

The 1889 Pulaski County Courthouse, located at Second and Spring streets, was built at a cost of $100,000. The courthouse rotunda features a Louis Comfort Tiffany stained-glass ceiling and beneath it a statue of Casimir Pulaski, the Polish officer who helped train American cavalry during the Revolutionary War and for whom the county is named.

STRICTLY MODERN

(1900–1919)

Detail of the 1881 U.S. Post Office and Courthouse. The edifice would endure through time and stands today at 300 West Second Street.

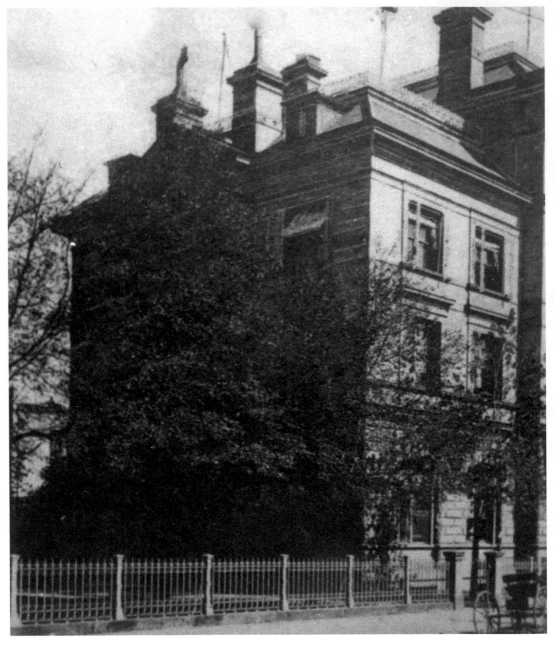

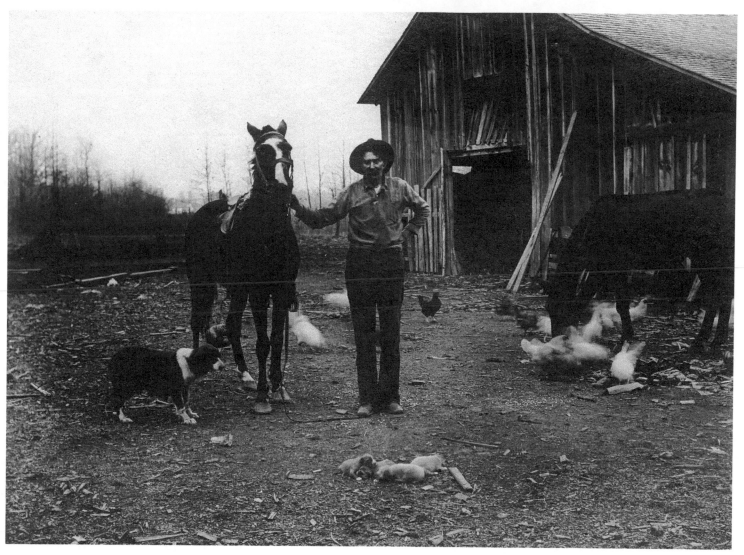

John Jacobs stands surrounded by barnyard animals on a farm near Kanis Road.

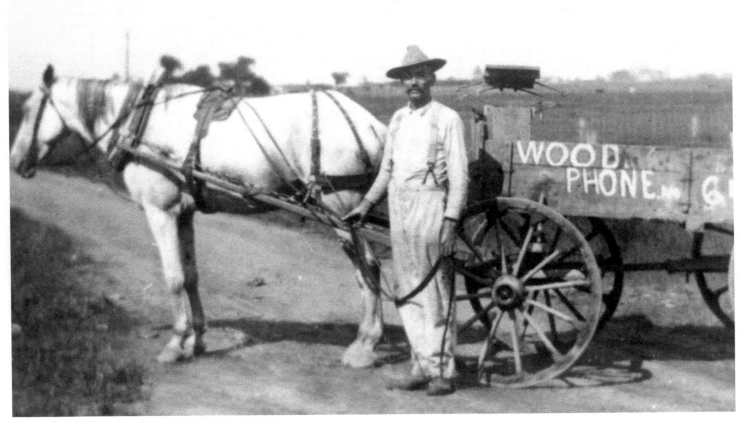

W. Siders, standing with horse and buckboard near Seventeenth and Main streets, seems to be having a sale on wood. Interested parties could reach him at phone 64. Horse-and-buggy transportation would not give way to the automobile until the new century was well under way.

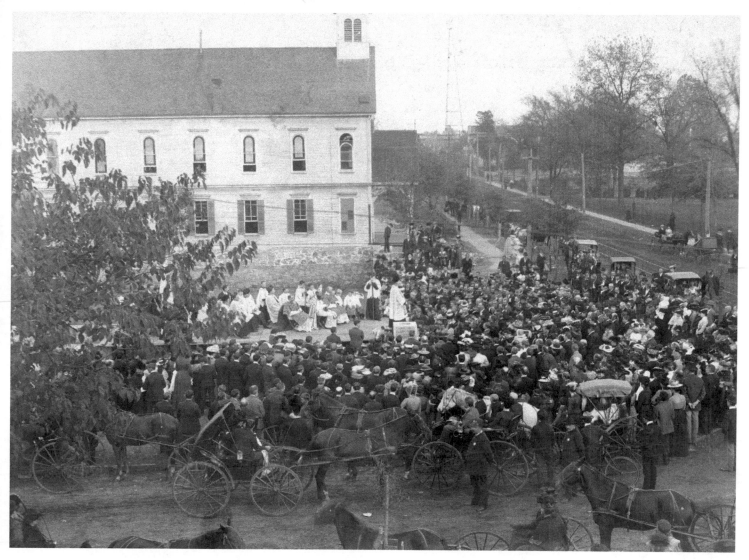

Parishioners gather for a ceremony to celebrate the laying of the cornerstone at St. Edward's Catholic Church on November 10, 1901.

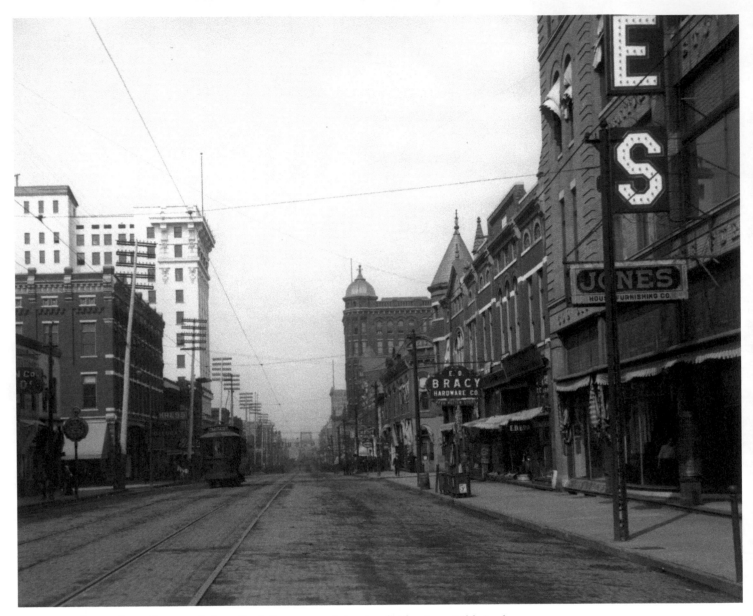

This view of Main Street faces north from Sixth Street toward the river bridge, just visible in the distance, which carried citizens into Argenta, separately incorporated as North Little Rock in 1901. Downtown thoroughfares by this time had been paved, and the streetcar lines had long since been converted to electric power.

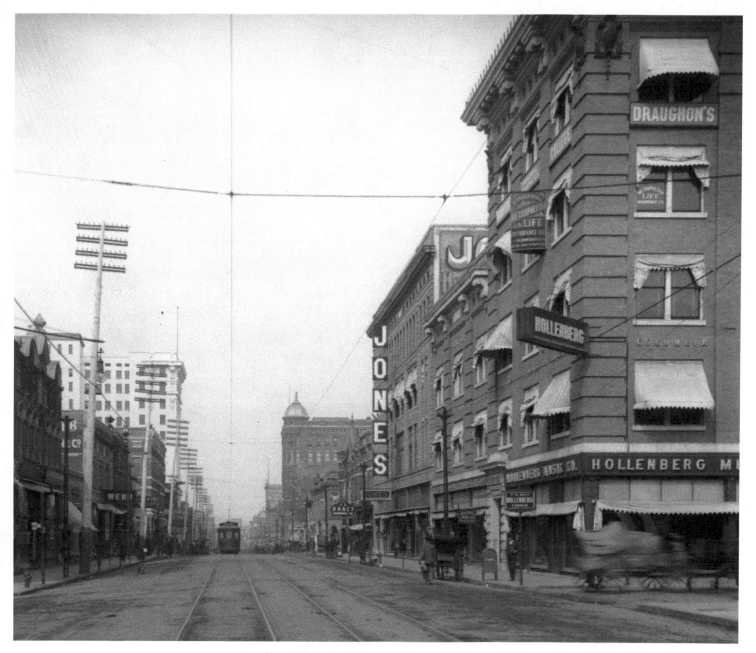

Another view of Main Street, facing north from Sixth Street. Open for business at the corner are Hollenberg Music Company and Metropolitan Life.

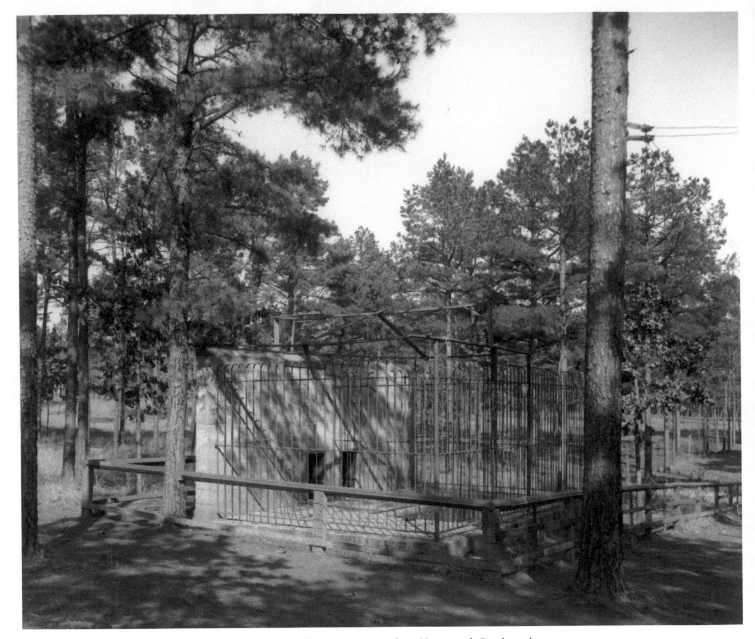

The bear pits in Forest Park, as they appeared in the early 1900s. Located on Kavanaugh Boulevard, Forest Park is occupied today by homes and businesses.

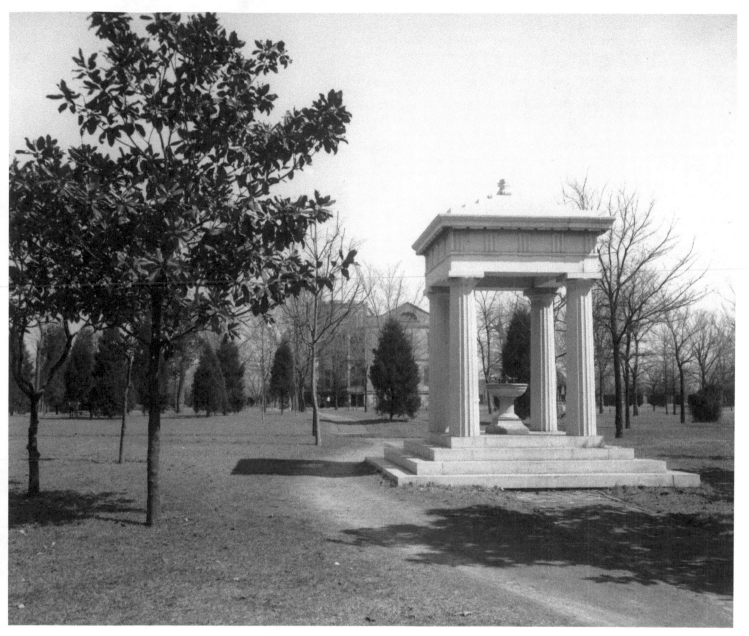

A memorial fountain in City Park, inscribed with the name "Gilbert Knapp." Knapp had owned land near the Toltec Mounds in Scott, Arkansas. Park flora included a lone magnolia tree putting down roots (at left), and a grove of cedars wintering over in the background.

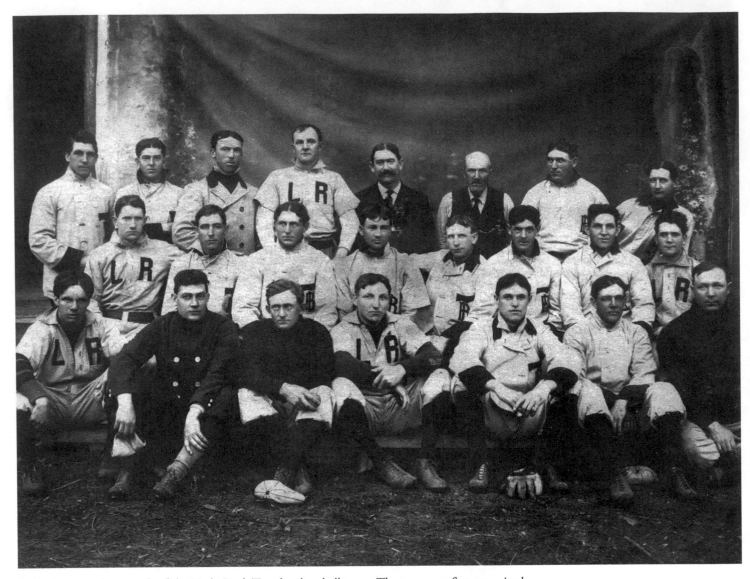

A 1902 group photograph of the Little Rock Travelers baseball team. The team was first organized in 1901. In 1957, they changed their name to the Arkansas Travelers, becoming the first professional team to name themselves after a state. The team also became one of the few franchises to be owned by the fans. Today the Travelers play at Dickie Stephens Park in North Little Rock and are affiliated with the Anaheim Angels.

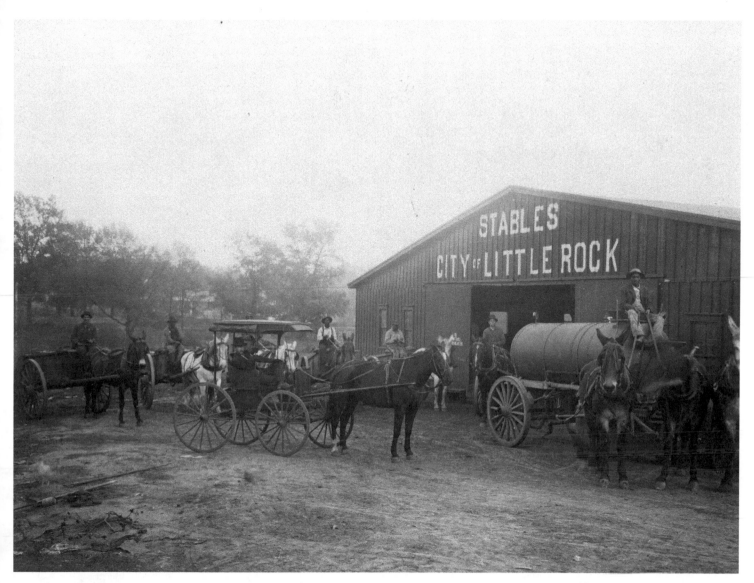

Stables for the city of Little Rock.

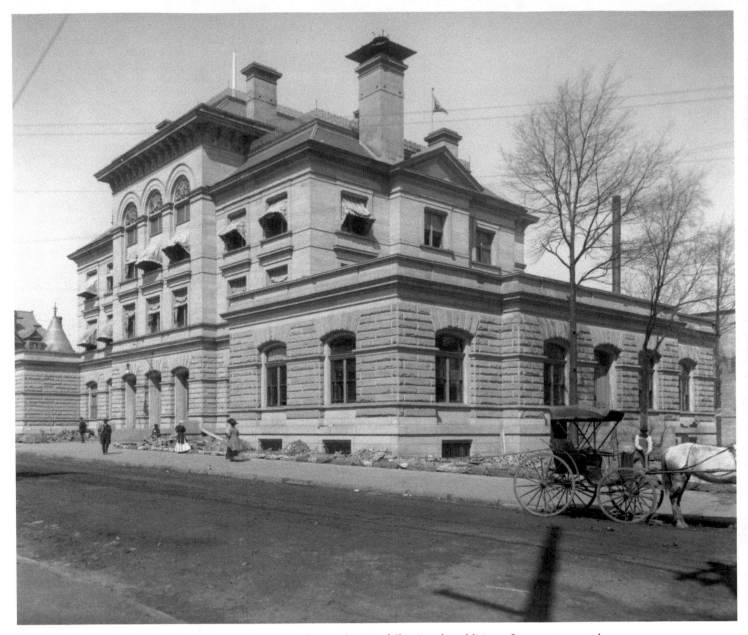

The Little Rock Post Office, this view probably recorded around 1910, following the addition of two wraparound wings to the Italian Renaissance revival structure.

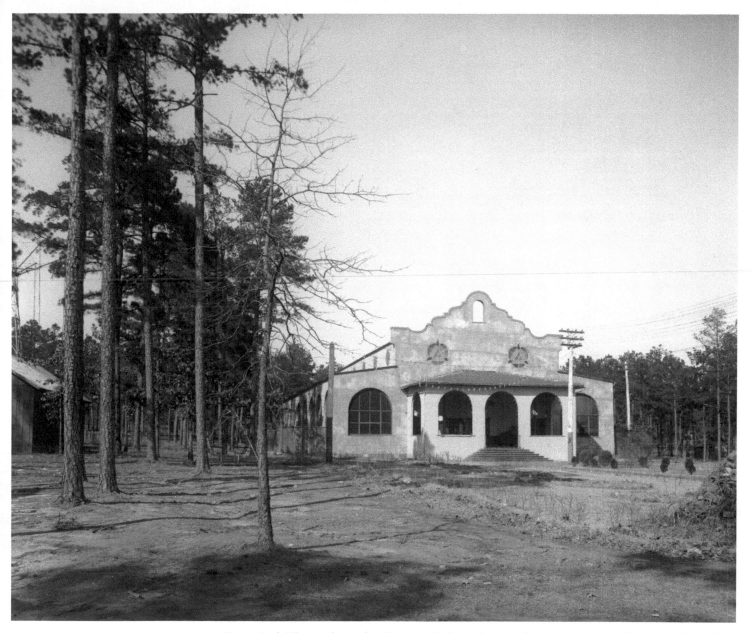

Forest Park Theater, located in Forest Park, hosted minstrel shows, concerts, plays, and silent films. The celebrated actress Sarah Bernhardt reportedly once appeared in *Camille* at the theater.

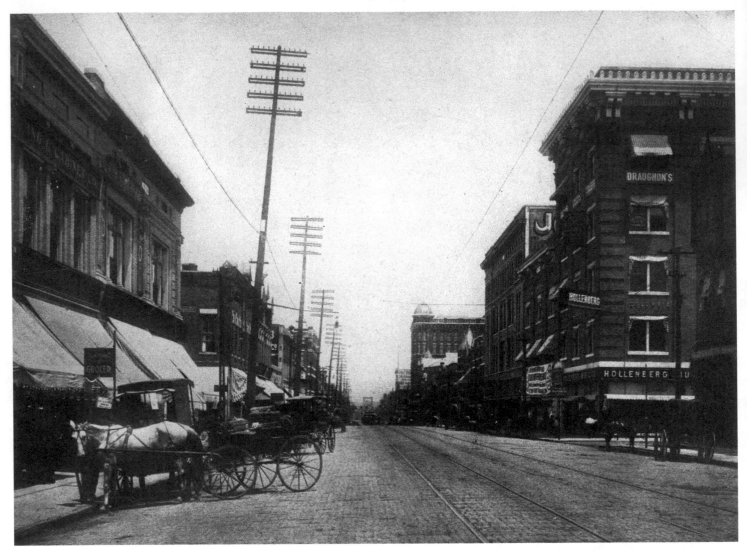

This is horse-and-buggy-days Main Street, facing north toward the river, from Seventh Street.

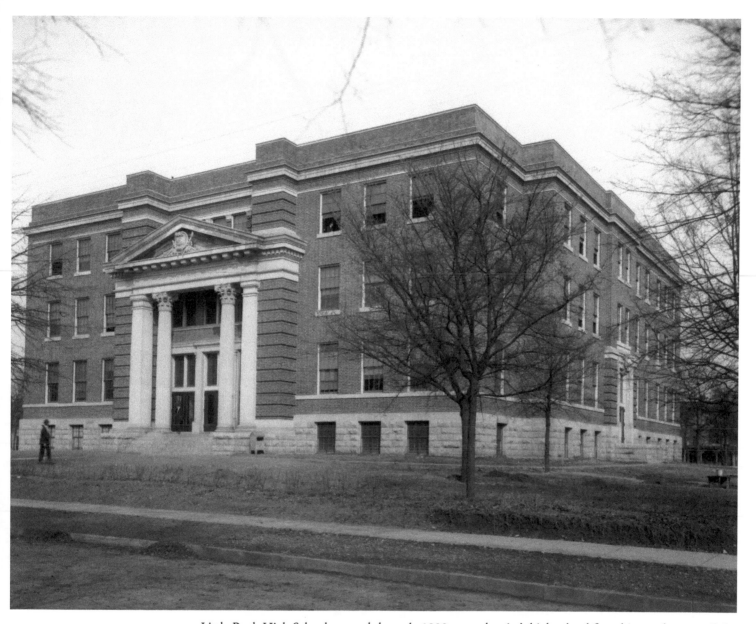

Little Rock High School, around the early 1900s, was the city's high school for white students until the opening of Central High School in 1927. The building served many purposes until it was closed in 1997.

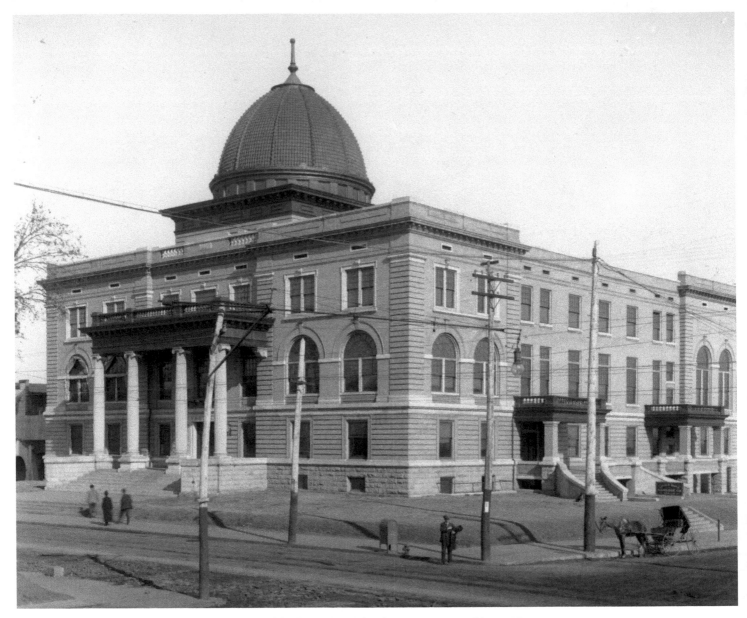

City Hall was designed by Charles Thompson and built in 1908. The dome was removed in 1956.

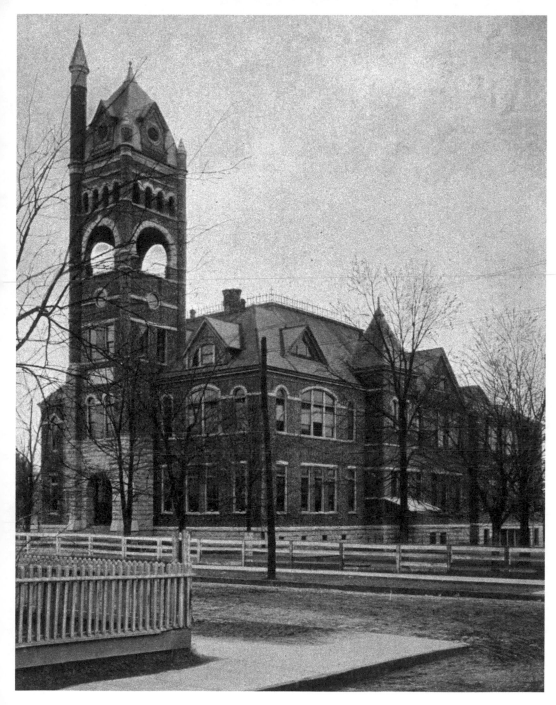

The Fred Kramer School, located on Sherman Street, around 1905. The school was built in 1895 and is the oldest surviving school building in Little Rock. In 1997, the structure became a resident artists' gallery.

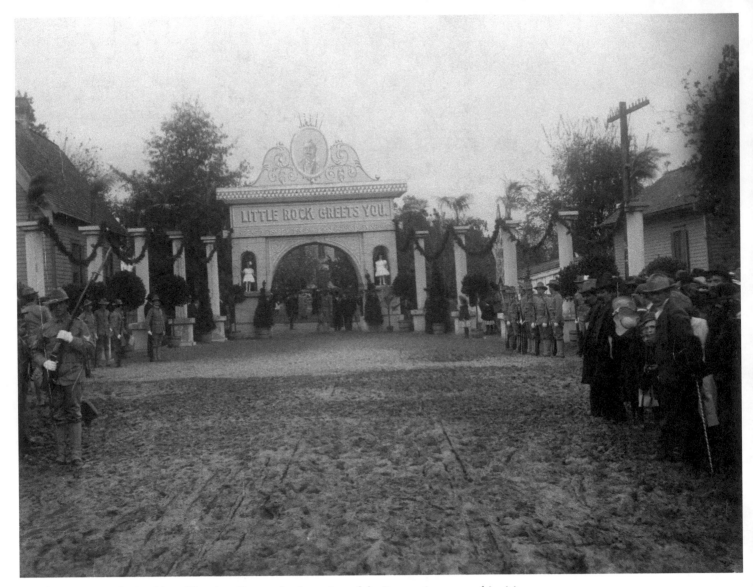

A welcoming gate for President Theodore Roosevelt, champion of the Progressive era, on his visit to Little Rock on October 25, 1905. Little Rock was a stop on the president's trip through the southern states. He made several speeches in the city, including one at City Park.

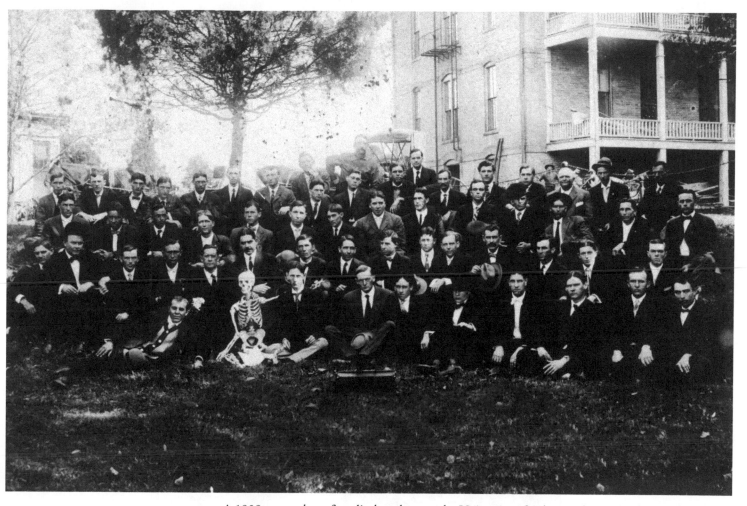

A 1908 group shot of medical students at the University of Arkansas for Medical Sciences. UAMS was founded in 1879 and today is the state's premier medical facility. It appears that the mascot for anatomy class campaigned for a spot in this class portrait.

A physical geography class takes a field trip to Pulaski Heights in 1908. Pulaski Heights, dating to the early 1890s, was one of Little Rock's first suburbs. It was incorporated by the city in 1916.

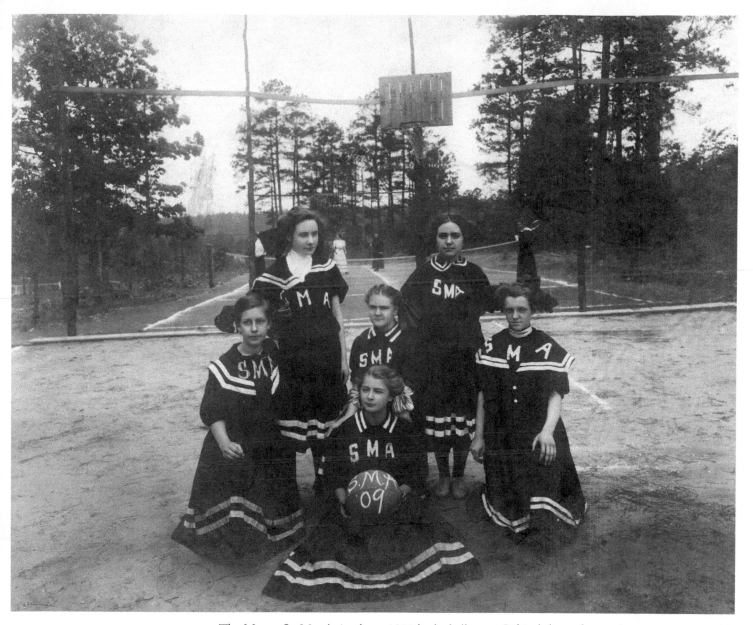

The Mount St. Mary's Academy 1909 basketball team. Behind these players, four women pose with racquets on a tennis court in what is evidently a doubles match in progress. Sports facilities have not always been well-endowed. This basketball court features a bare-earth surface and a backboard made of what appear to be boards from old shipping crates.

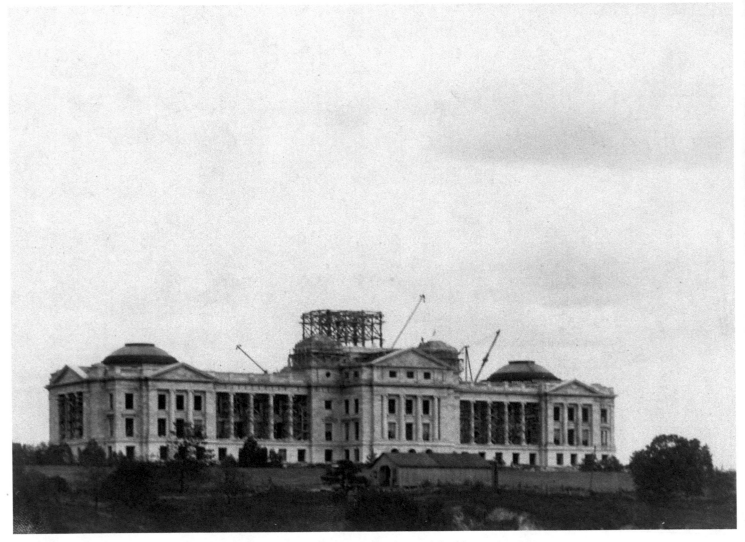

Construction of the Arkansas State Capitol as it appeared around 1910. The work had begun in 1899 but the Capitol was not completed until 1915, delayed by inefficiency and a bribery scandal. The edifice is a smaller-scale replica of the nation's Capitol in Washington, D.C.

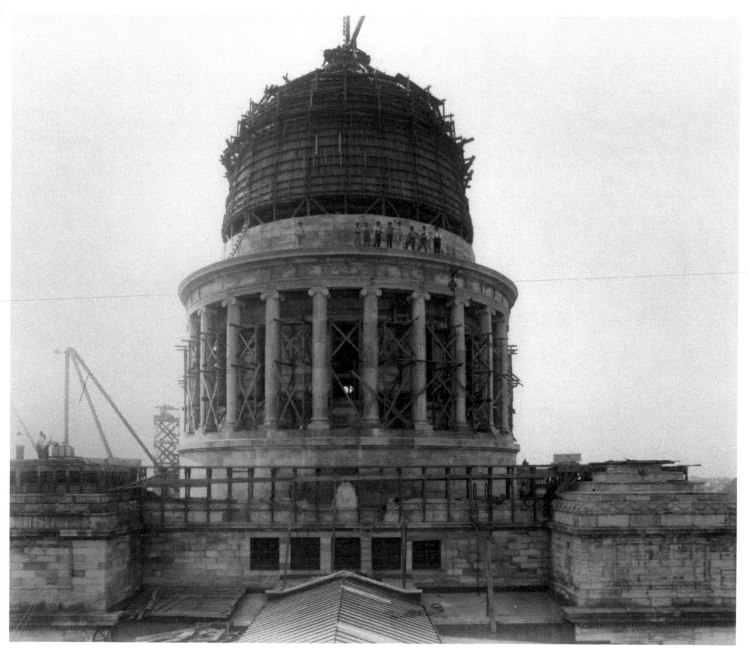

Construction of the Arkansas State Capitol, showing work in progress on the dome.

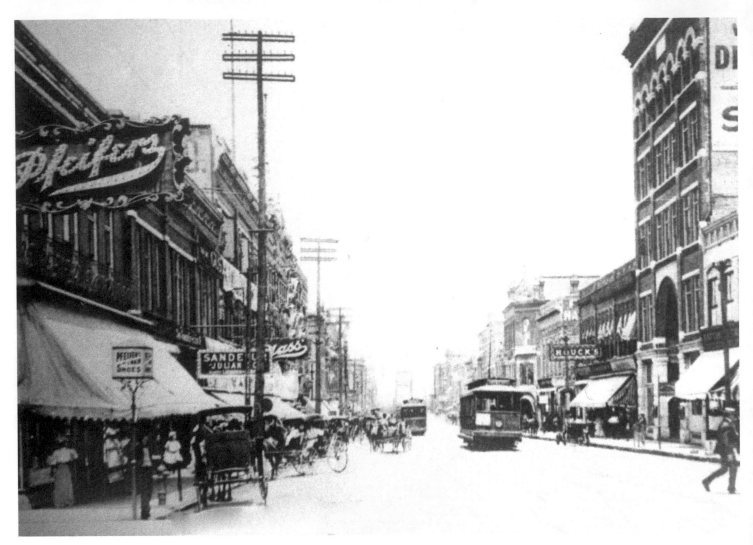

A single automobile is visible in this early 1900s view of downtown Little Rock.

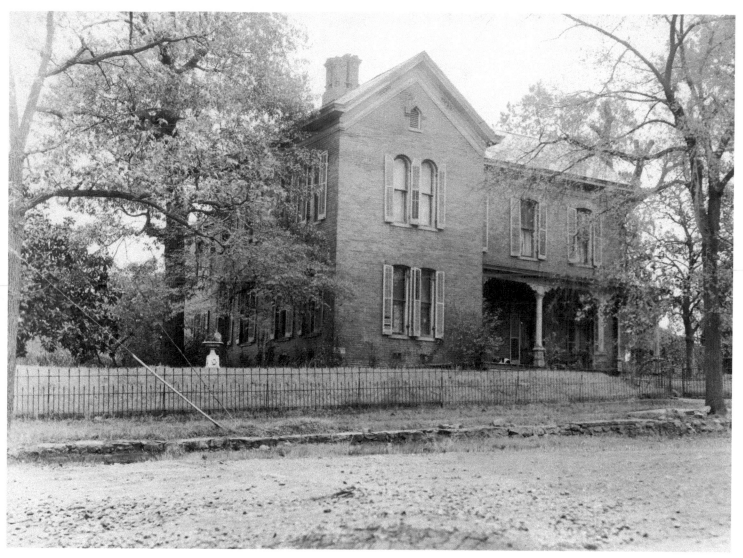

The George Reichardt House, located at 505 Rector Avenue, around 1910.

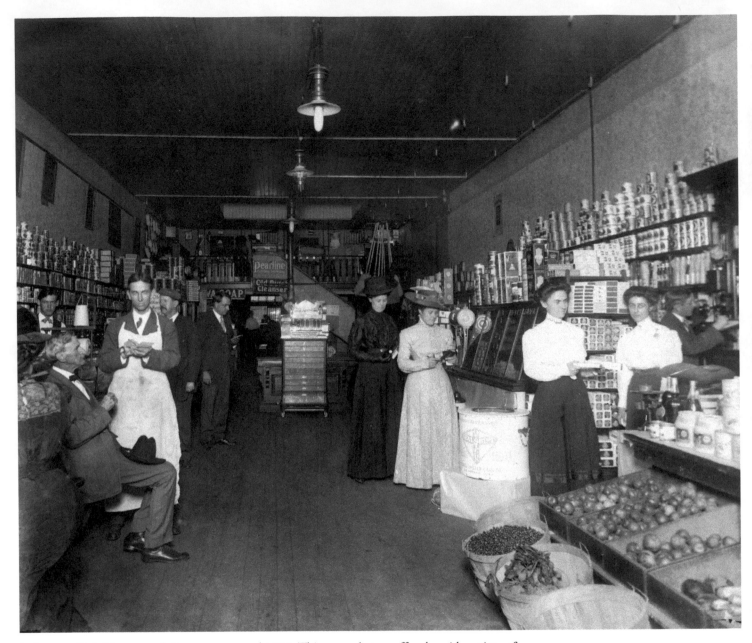

Indoors at C. J. Kramer and Company, around 1910. This general store offered a wide variety of products. On the shelf at right are boxes of Zu Zu gingersnaps, an early product of the National Biscuit Company, familiar today as Nabisco.

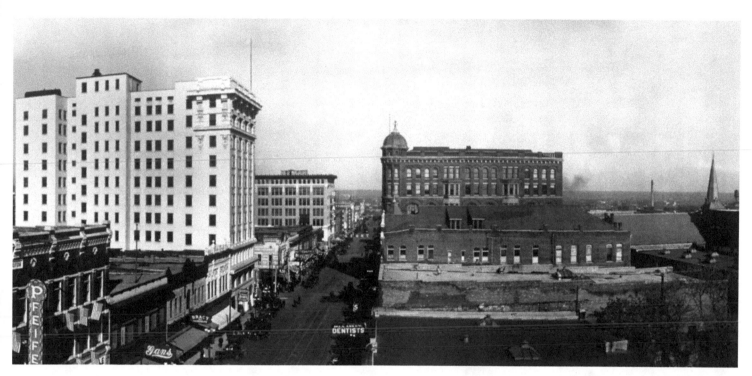

Bird's-eye panorama of Little Rock.

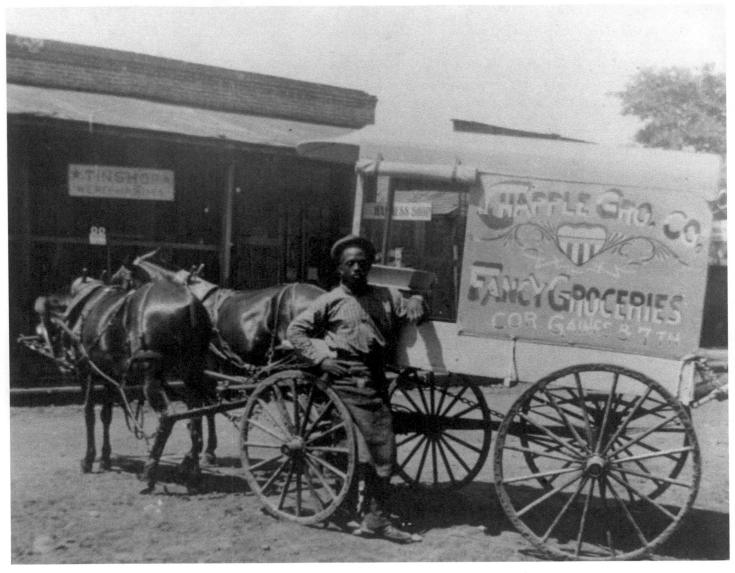

A horse-drawn delivery wagon for the Chapple Grocery Company, which was located at Seventh and Gaines.

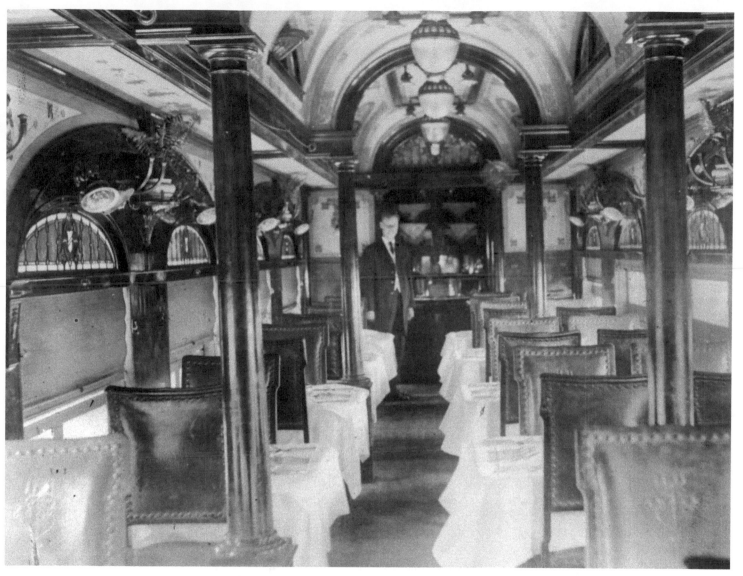

The dining car of the Donaghey and Bryan special train, with its plush interior and stained-glass transoms, is illustrative of the finest in railroad accommodations during the golden era of the railroads. From September 6 to 10, 1910, Governor George W. Donaghey and William Jennings Bryan toured Arkansas stumping for the adoption of the proposed Initiative and Referendum amendment to the state constitution. The tour covered 1,750 miles and included 55 speeches. The amendment passed, becoming the seventh amendment of article five in the constitution.

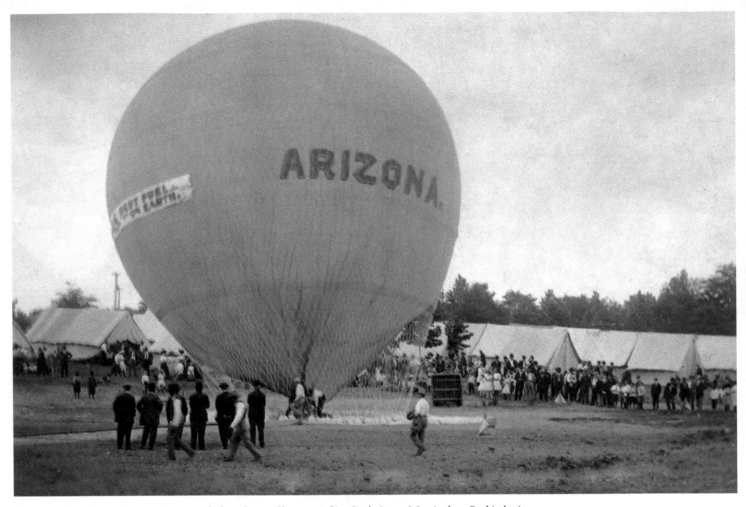

The hot-air balloon *Arizona* is grounded at Camp Shaver at City Park (now MacArthur Park) during the United Confederate Veterans Reunion held May 16-18, 1911. Camp Shaver provided free temporary housing for veterans during the reunion and consisted of approximately 1,330 tents. It was named for Colonel Robert G. Shaver, who commanded the Seventh Arkansas Regiment for the Confederate Army during the Civil War. This image and several to follow all depict various activities at the reunion.

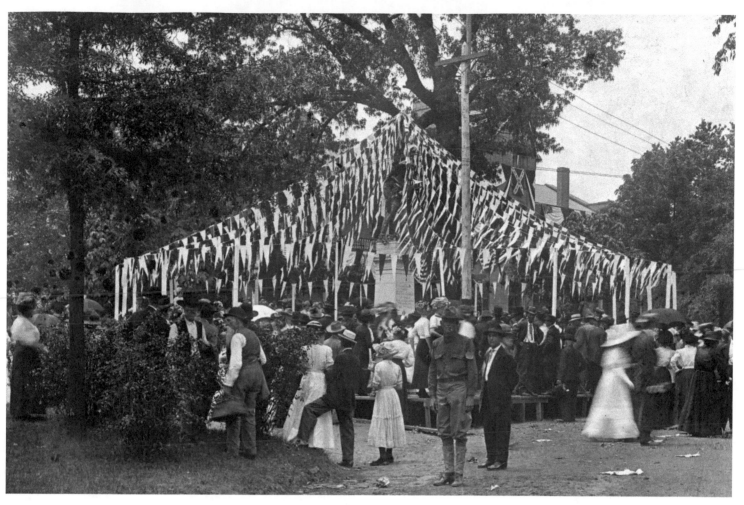

Spectators gather to watch the unveiling of a monument to the Capital Guard at City Park sometime during the May reunion. The monument was erected in memory of the members of Company A, Sixth Arkansas Infantry, Cleburne's Division, who fought during the Civil War.

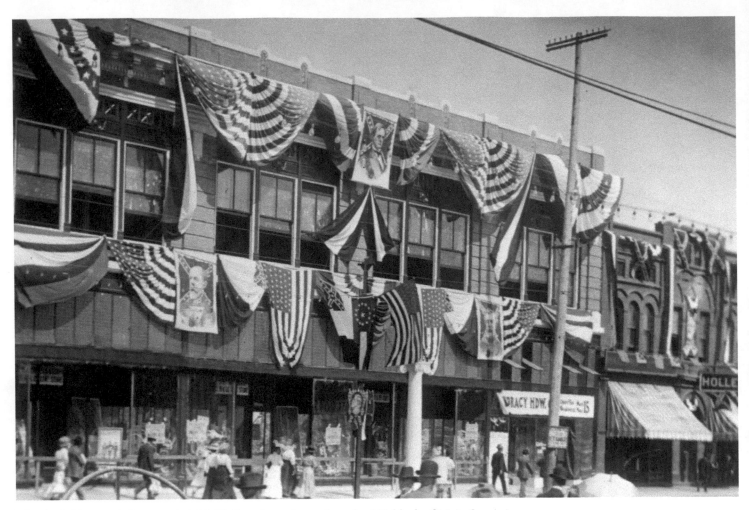

The S. H. Kress and Company's 5-10-15 Cent Store, located on the 600 block of Main Street, is decorated with banners and flags for the United Confederate Veterans Reunion on May 16.

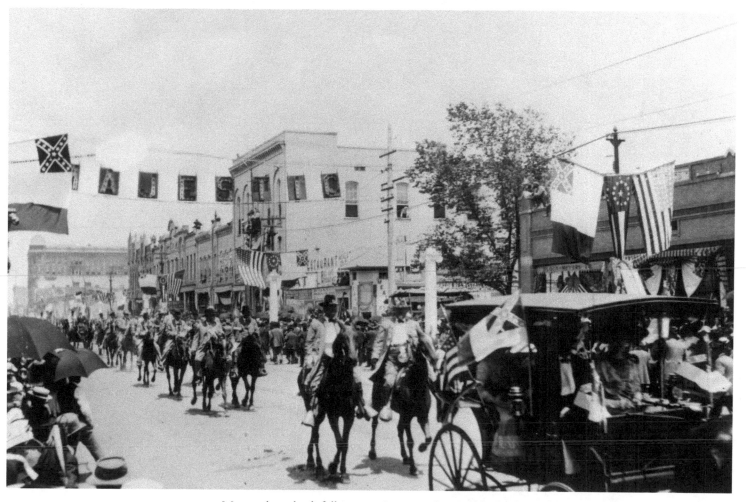

Men on horseback follow a carriage past the 800 block of Main Street in a parade on May 18. The parade, which ran from the Old State House to City Park and back again, was the highlight of the Confederate reunion. So many people participated that the parade needed two hours to pass any given observation point.

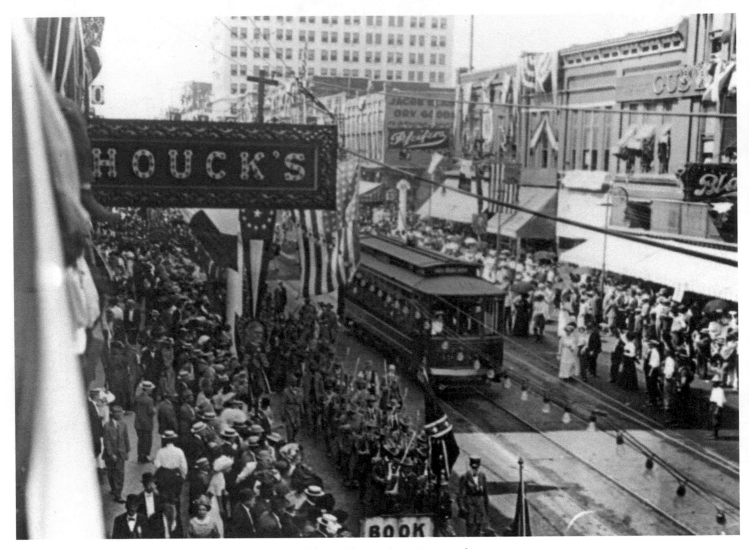

A view of the 300 block of Main Street during the Confederate Veterans' reunion parade.

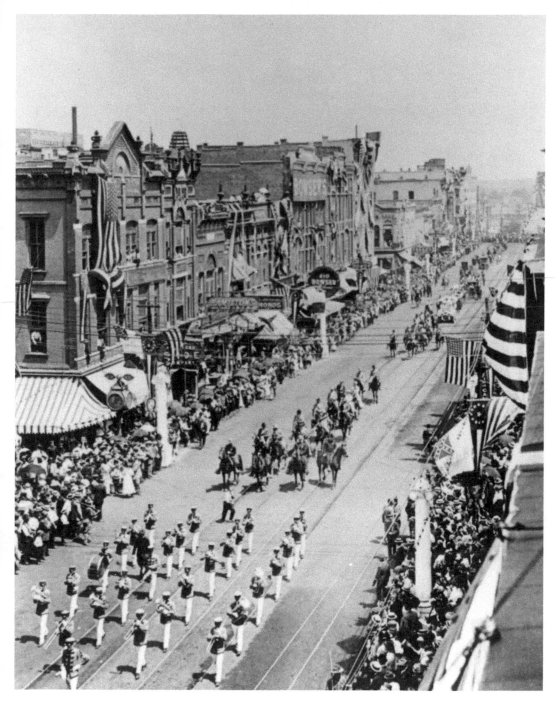

A rooftop view of the reunion parade in progress, facing north toward the 200 block of Main Street.

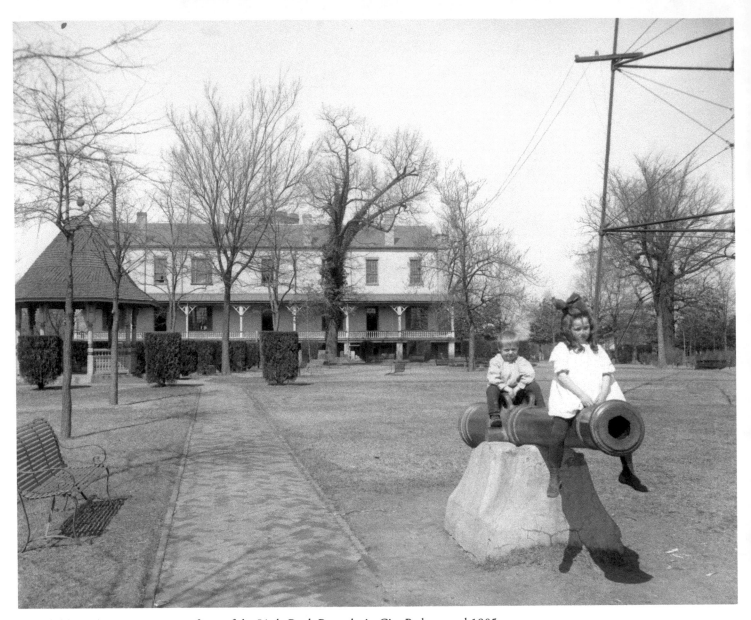

Two children play on a cannon in front of the Little Rock Barracks in City Park around 1905. The 12-foot brass cannon was forged in Spain in 1796 and captured in Cuba during the Spanish-American War. The city of Little Rock would donate the cannon to the war effort as scrap metal during World War II.

An automobile travels down West Second Street in the early 1900s.

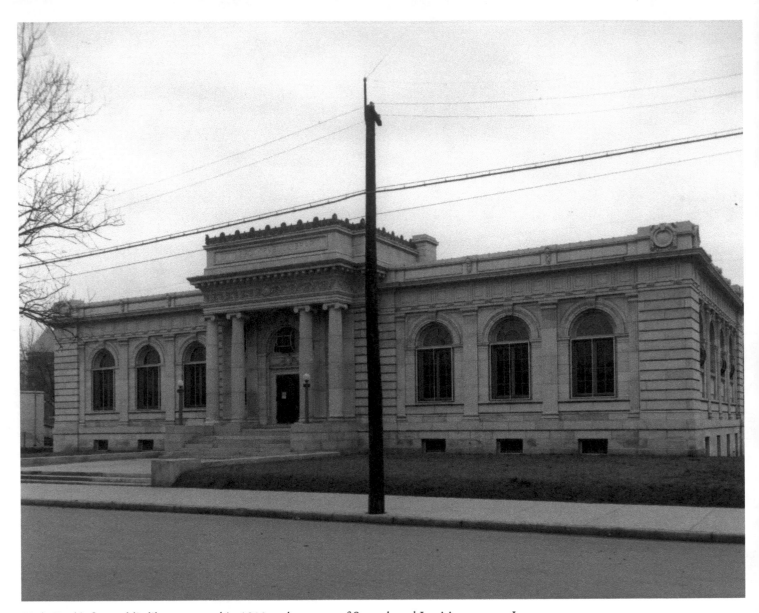

Little Rock's first public library opened in 1910 at the corner of Seventh and Louisiana streets. It was designed by local architect Charles L. Thompson and, like so many libraries across the nation of the day, was made possible through funds given by steel magnate and philanthropist Andrew Carnegie. Some of the libraries Carnegie funded thrive today. This one was leveled in 1963.

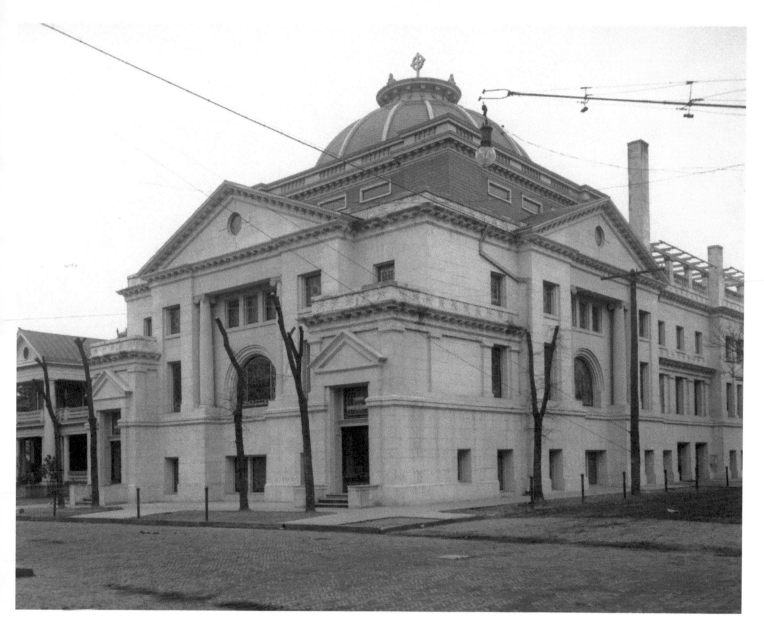

Little Rock's Second Baptist Church.

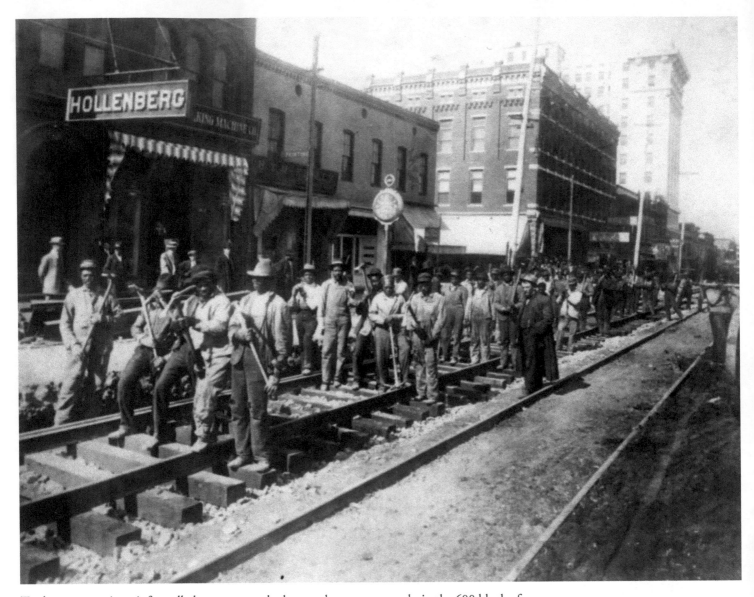

Trackmen, sometimes informally known as gandy dancers, lay streetcar tracks in the 600 block of Main Street in the early 1900s.

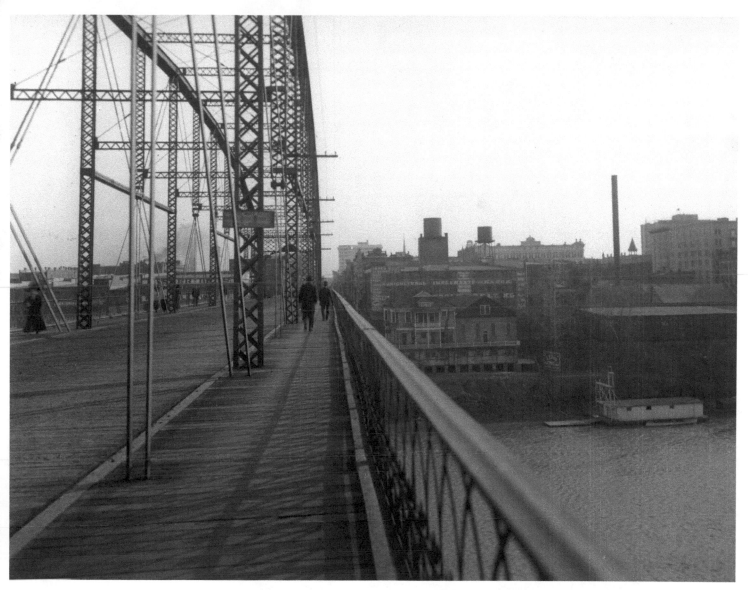

A view of Little Rock from the Free Bridge. The Free Bridge, built in 1897, was the first bridge in the city to span the Arkansas River designed not for use by a railroad, but for pedestrian and wagon traffic. No toll was collected on the road, hence the name "Free" Bridge.

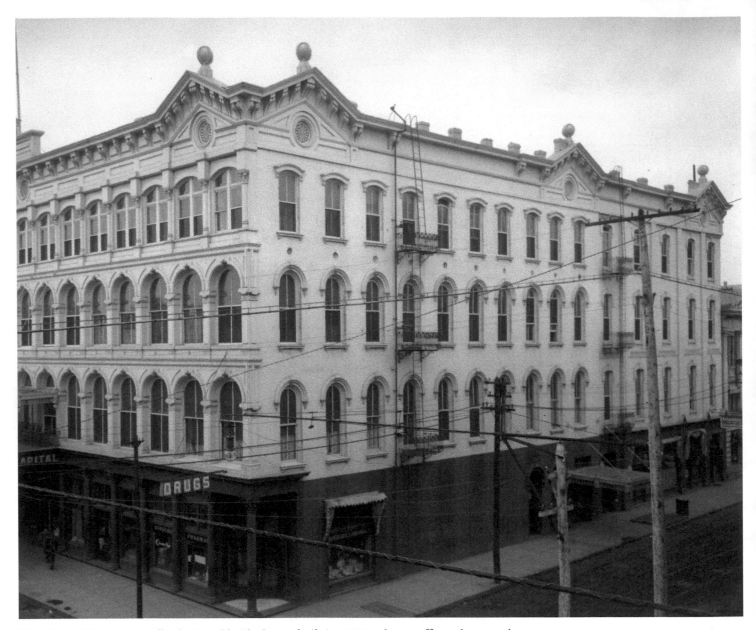

The Capital Hotel, originally the Denckla Block, was built in 1872 to house offices, shops, and gentlemen's apartments. It reopened as a hotel in January 1877 after the Metropolitan Hotel burned. More than a century later, in 1983, it reopened again, restored to its original opulence.

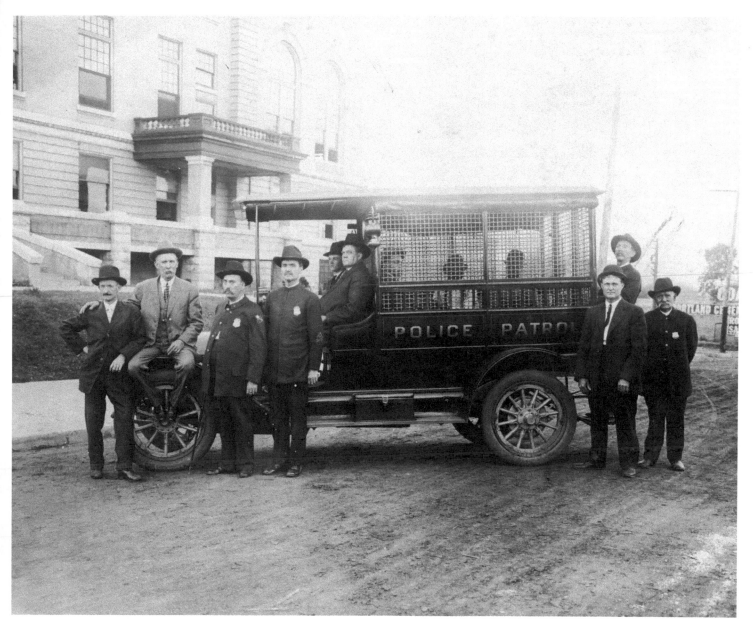

Members of the Little Rock Police Patrol pose for a group shot in front of City Hall around 1915.

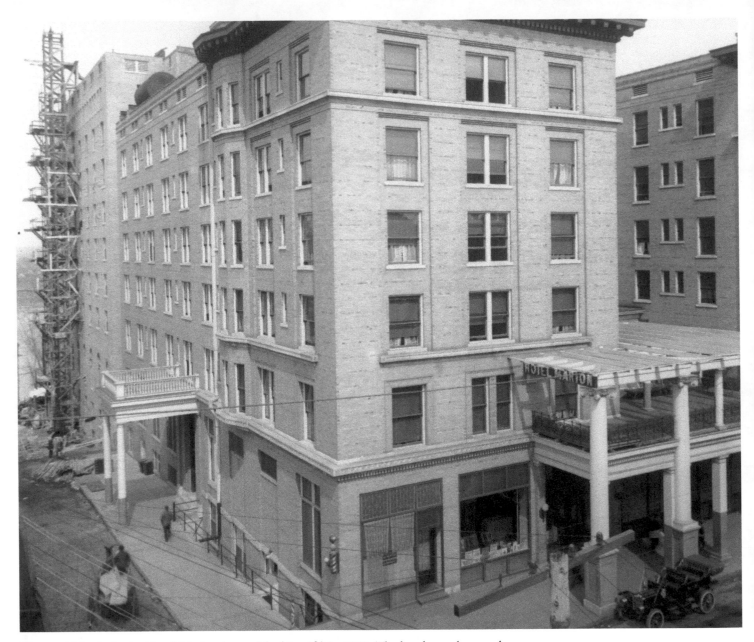

Herman Kahn built the Hotel Marion (named for his wife) in 1905. The hotel soon became known as "the meeting place of Arkansas." It closed in the 1970s and was demolished in 1980 to make way for the Excelsior Hotel (now the Peabody Hotel) and a convention center.

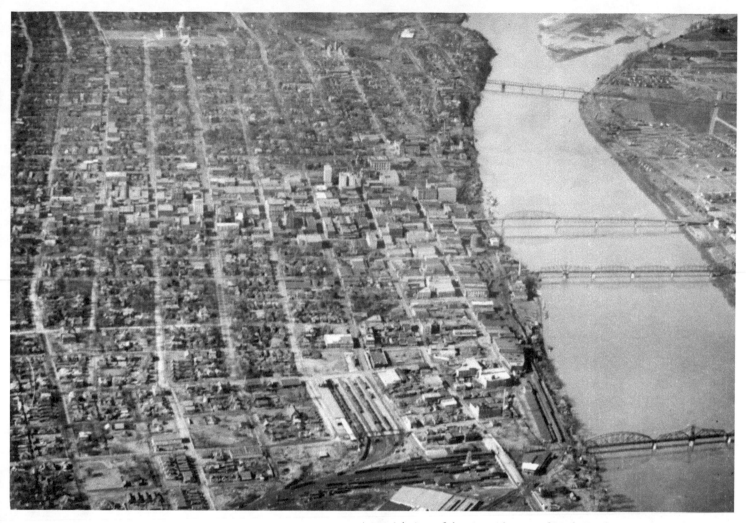

An aerial view of the riverside area of Little Rock as it appeared in 1918.

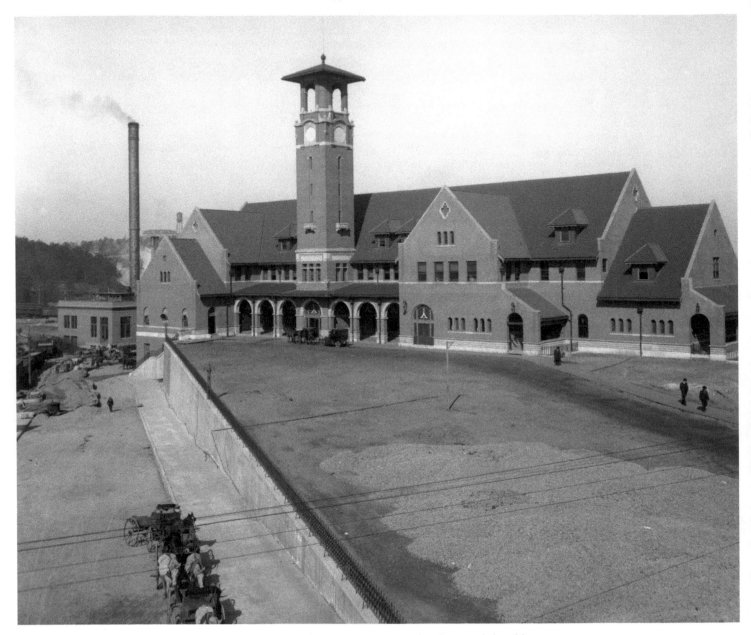

Little Rock's Union Station at 1400 West Markham was built in 1921 after a fire destroyed the older terminal. Today the handsome structure is home to other commercial interests, but Amtrak also uses part of the building.

Collisions

(1920–1939)

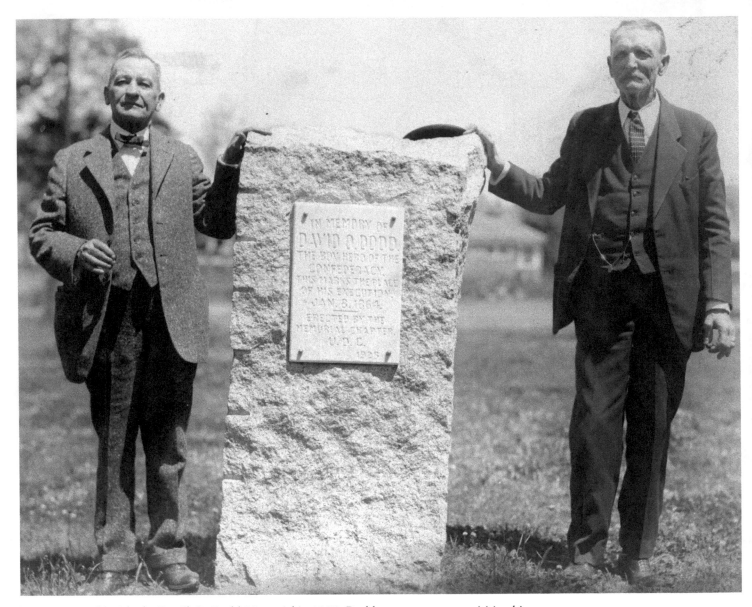

Two men stand beside the David O. Dodd Memorial in 1925. Dodd was a young man visiting his family during the Christmas holidays after the Union occupation of Little Rock began in 1863. Dodd was arrested behind enemy lines and accused of being a Confederate spy after coded papers were found in his boot. He was tried and hanged on January 8, 1864, and is buried at Mount Holly Cemetery.

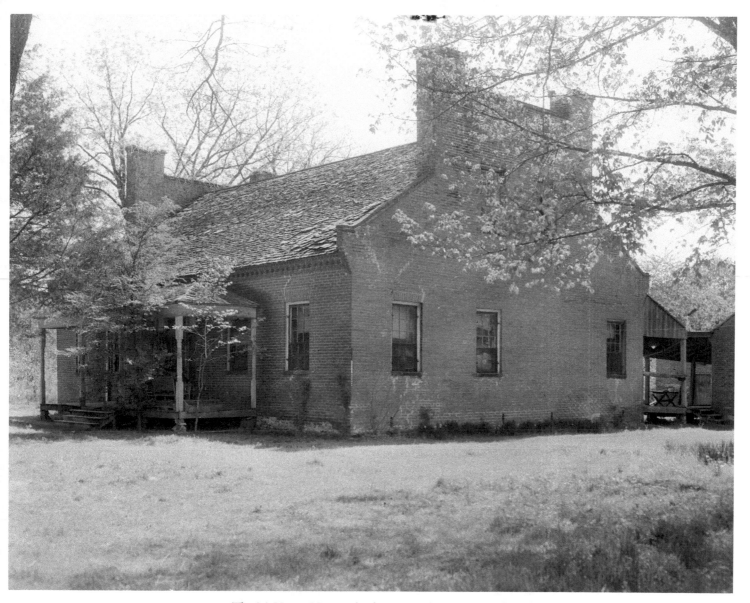

The McHenry House, also known as the Ten Mile House or the Stagecoach House, is located on Highway Five and is shown here as it appeared in 1933. It was built by Archibald McHenry sometime between 1825 and 1836 and was a stopping point on the Southwest Trail stagecoach line. Union Troops commandeered the house during the Civil War. Its smokehouse served as a prison for David O. Dodd before his trial.

The Wallace Building, one of the many projects of prolific architect George Richard Mann, was built on the southeast corner of Main and Markham streets. Mann was the man behind many of Little Rock's better known buildings constructed in the early twentieth century.

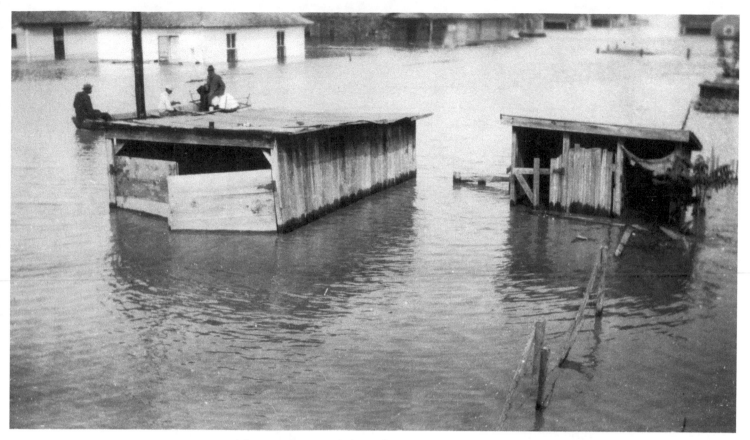

This view faces north from the corner of East Ninth and Foster streets during the flood of 1927.

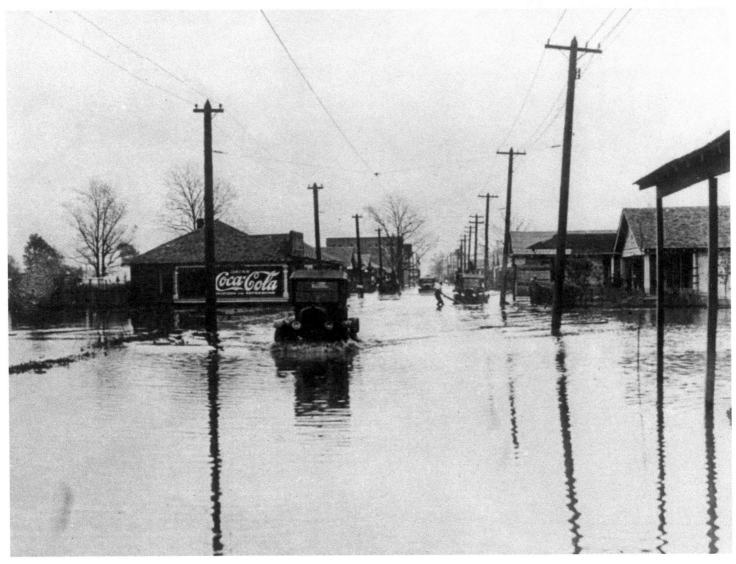

Automobiles are axle-deep in floodwaters that have hit East Little Rock, shown in this view from the 1920s.

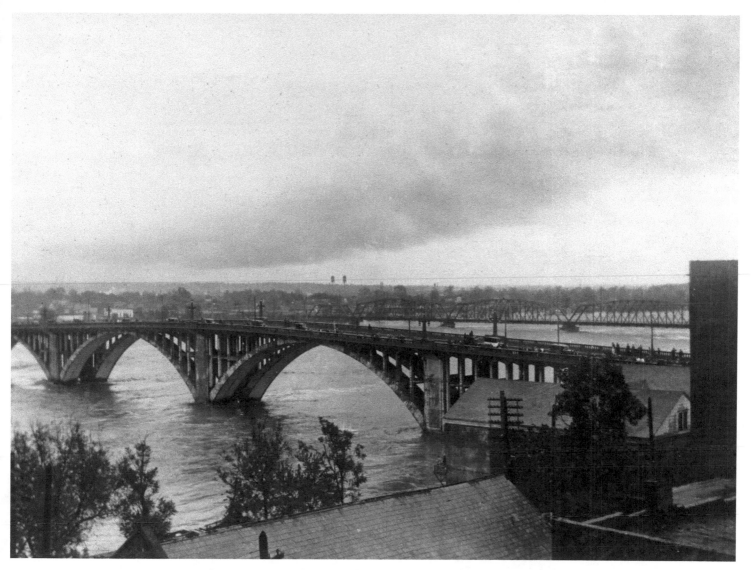

Spectators watch the raging floodwaters of the Arkansas River from the Main Street Bridge during the Great Flood of 1927. The flood was the most destructive in Arkansas history, and similar inundations swept many towns and communities across the United States, especially in the South, presaging the nationwide hardships to follow with the coming of the Great Depression. Thirty-six of the 75 counties in Arkansas were flooded, and 100 Arkansans died.

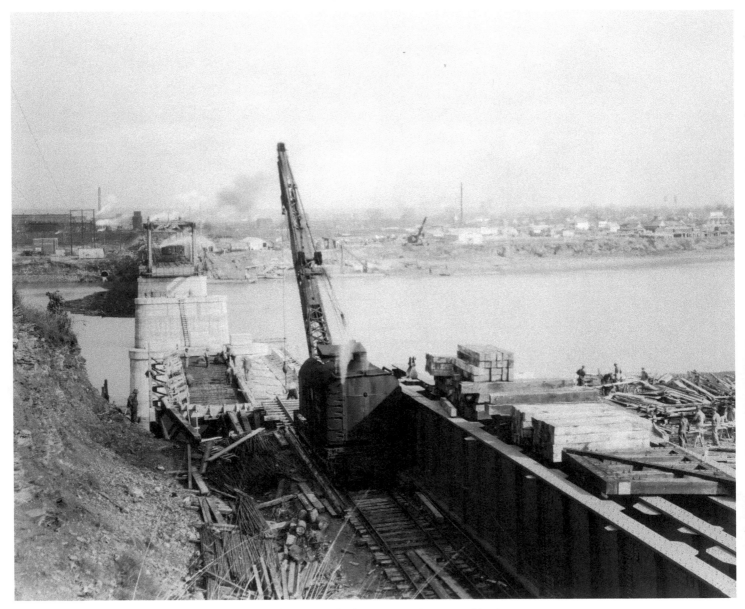

Construction of the new Baring Cross bridge is under way in the late 1920s. The original bridge was named for Baring and Company, the London bank that financed the project. The president of the Cairo and Fulton Railroad Company added the word "cross." When the original bridge washed away in the deluge of 1927, the Missouri Pacific Railroad pledged to rebuild it. The new bridge opened in 1929.

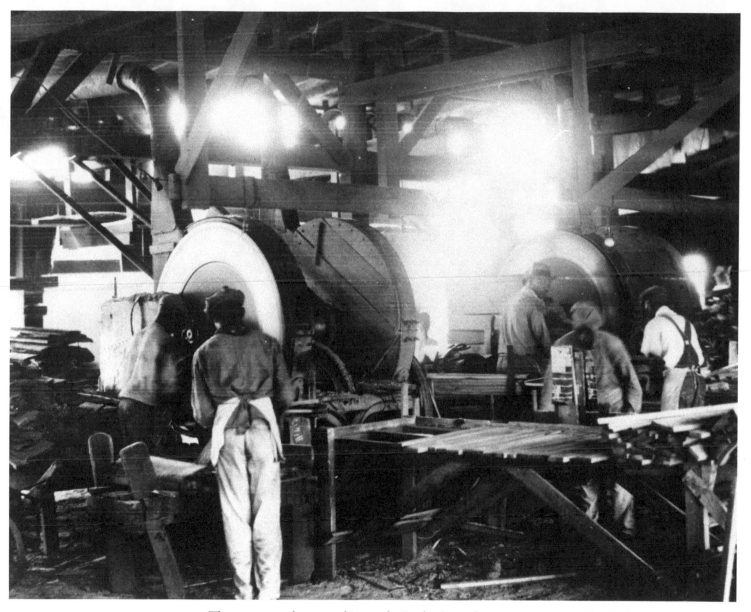

These men are shown working at the Jamlin Stave Company on August 21, 1928. Staves were narrow strips of wood used in the manufacture of barrels.

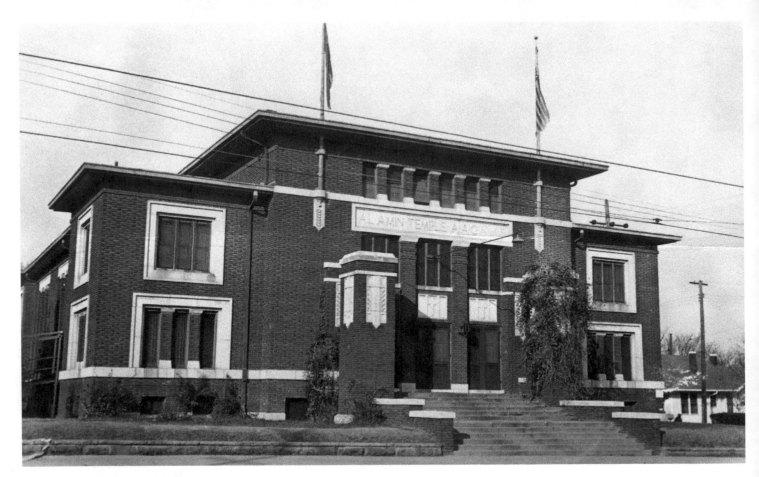

The Al Amin Shrine Temple in 1933.

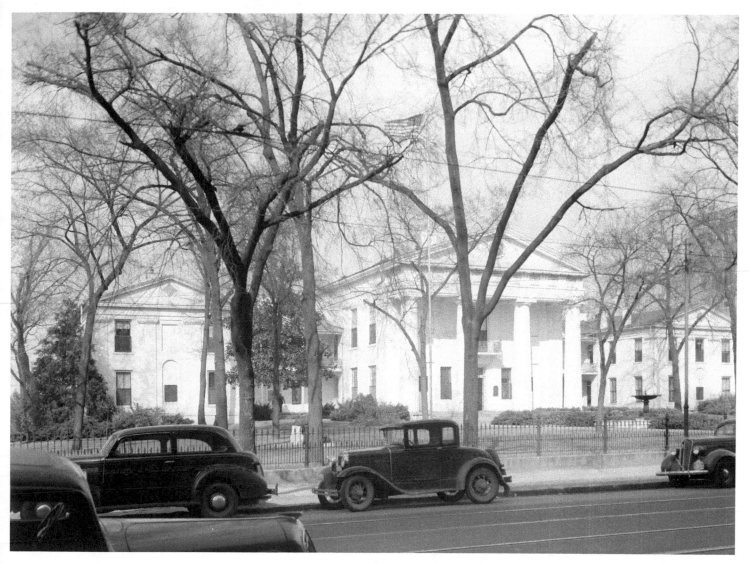

The Stars and Stripes flies over the Old State House on April 12, 1934.

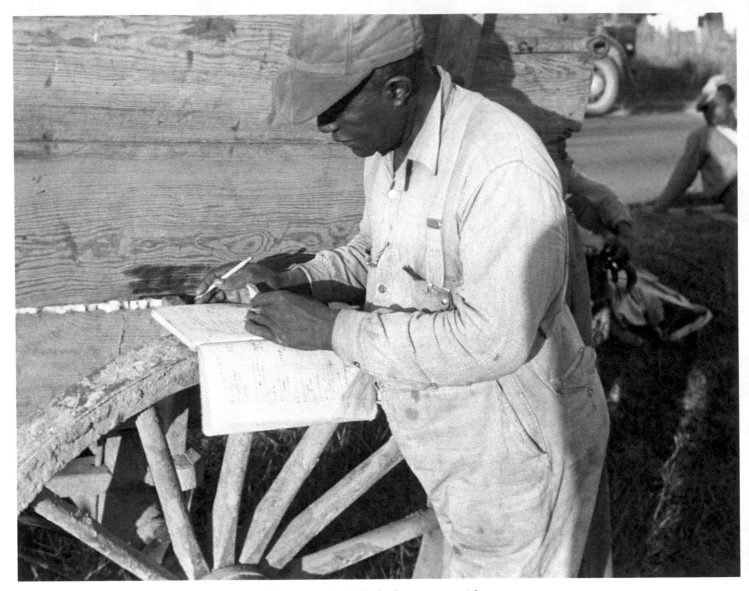

A Little Rock worker checks in cotton in 1935. Cotton remained the leading commercial crop throughout most of Arkansas in the 1930s. When the worst drought of the twentieth century struck the area in 1930 and 1931, farmers were hard hit, relying on hunting, fishing, and turnips for sustenance.

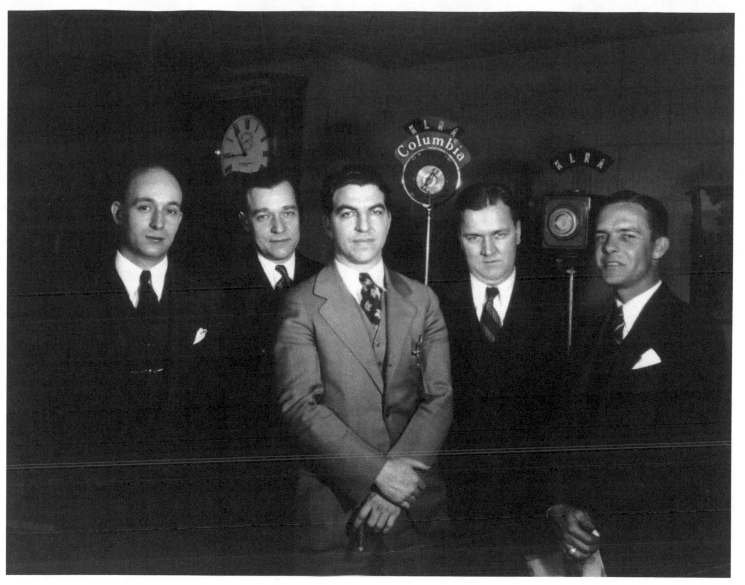

Members of the Columbia System and Red Cross staff met at the KLRA radio station on Janury 31, 1931, to discuss plans for a drought relief program. In January 1931, the Red Cross initiated the program, helping alleviate the shortage of basic necessities by mid-1931.

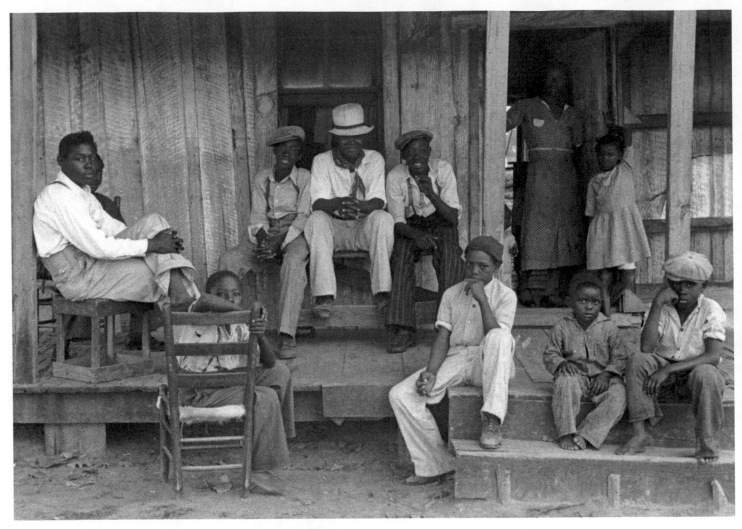

A family of sharecroppers gather together in 1935. After the Civil War, farm economies in the South, Arkansas among them, depended on the labor of disadvantaged black and white Americans working the land to eke out a living. Landowners provided the acreage and equipment, sharecroppers provided the labor, and profits were to be shared. Mechanization and other changes would lead to the decline of the much-criticized system.

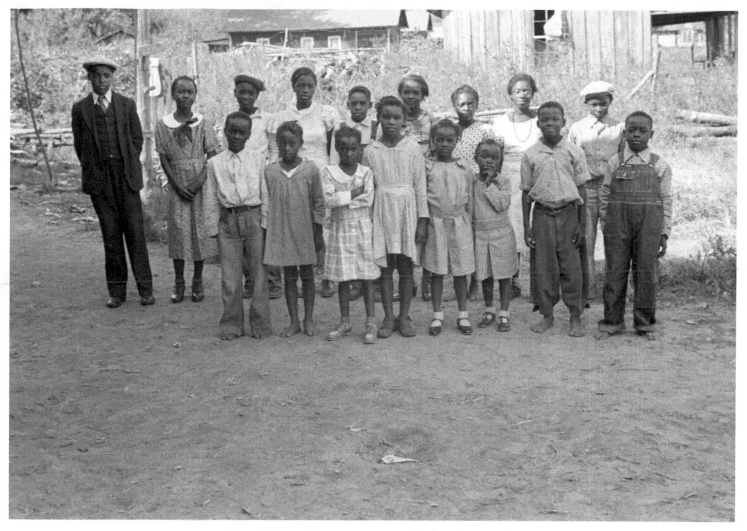

The children of sharecroppers pose for the photographer in October 1935. Americans everywhere were struggling through the worst of the Great Depression.

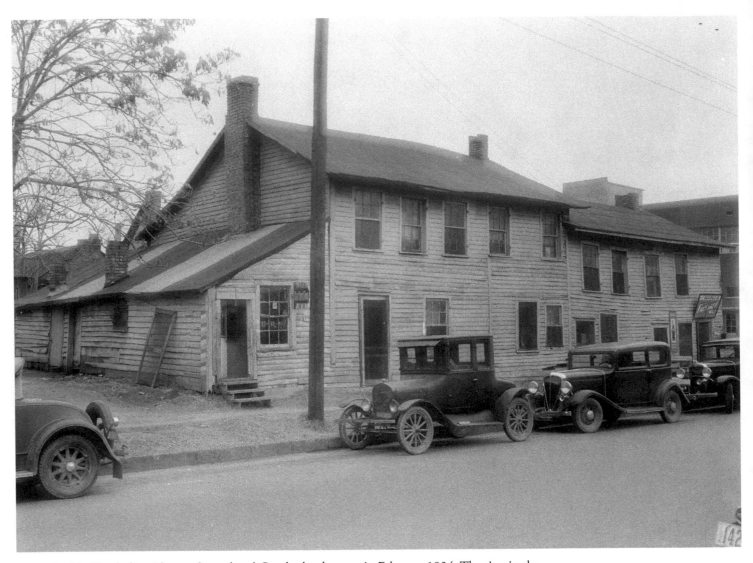

A ramshackle Henderliter Place at Second and Cumberland streets in February 1934. The sign in the barbershop window at center says "U-R-Next." At far-right, signage advertises soft drinks, barbecue, and beer. The two-seater Model T Ford coupe, parked beside the telephone pole, marks automotive designs of an era gone by—the last Model T had come off Henry Ford's assembly line in 1927.

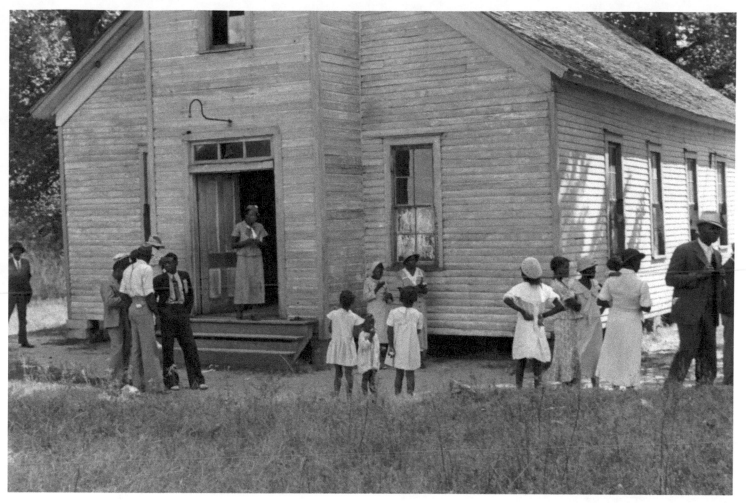

A typical October Sunday in Little Rock in 1935.

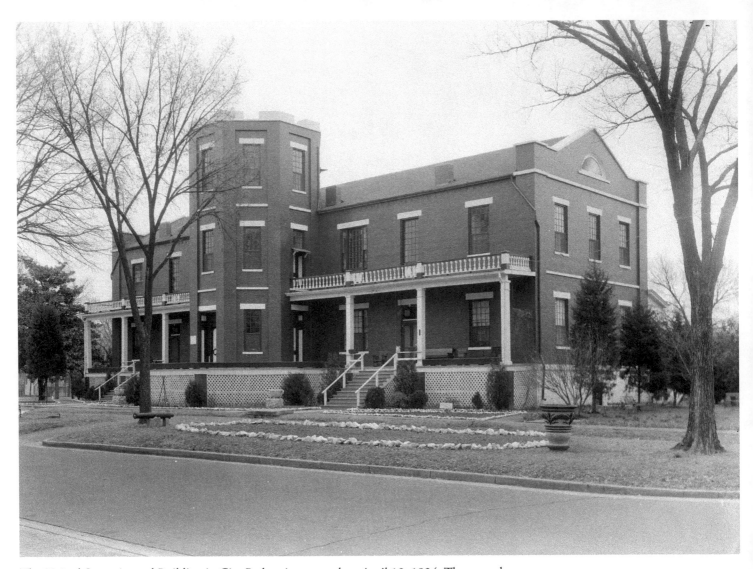

The United States Arsenal Building in City Park as it appeared on April 12, 1934. The arsenal was built in 1840, and General Douglas MacArthur was born here in 1880. Today the park is known as MacArthur Park and the building houses the MacArthur Museum of Arkansas Military History, in tribute to the illustrious general of World War II.

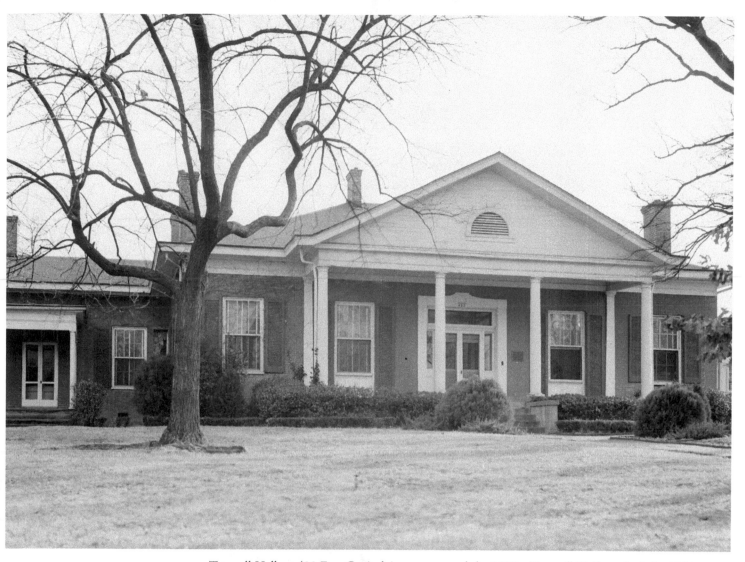

Trapnall Hall, at 423 East Capitol Avenue, around the 1930s. Trapnall Hall was built in 1843 as one of few brick homes in early Little Rock. It was owned by Martha and Frederic Trapnall, a merchant and lawyer who served in the Arkansas state legislature before the Civil War. Today the Greek Revival home has been restored and serves as the official receiving hall for governors of Arkansas.

These young boys reach the
summit of a soft-drink stand
in June 1938, waving to the
photographer in triumphant glee.

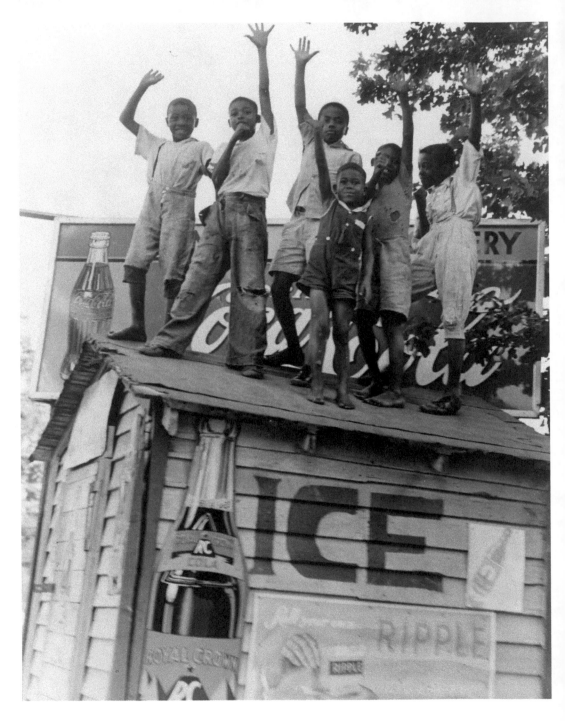

CRISIS AND REDEMPTION

(1940–1960s)

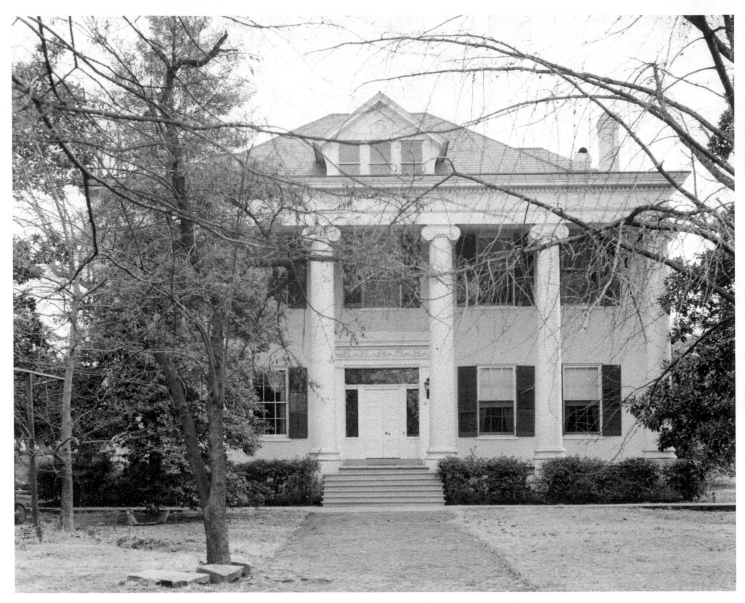

The Albert Pike House (now the Pike-Fletcher-Terry House) at 411 East Seventh Street, on March 1, 1940. Albert Pike, a Confederate general at the Battle of Pea Ridge, built the house in 1840. It was later the home of Pulitzer Prize–winning author John Gould Fletcher. Adolphine Fletcher Terry and her sister, Mary Drennan, left the mansion to the city of Little Rock in 1976. The Decorative Arts Museum opened here in 1985.

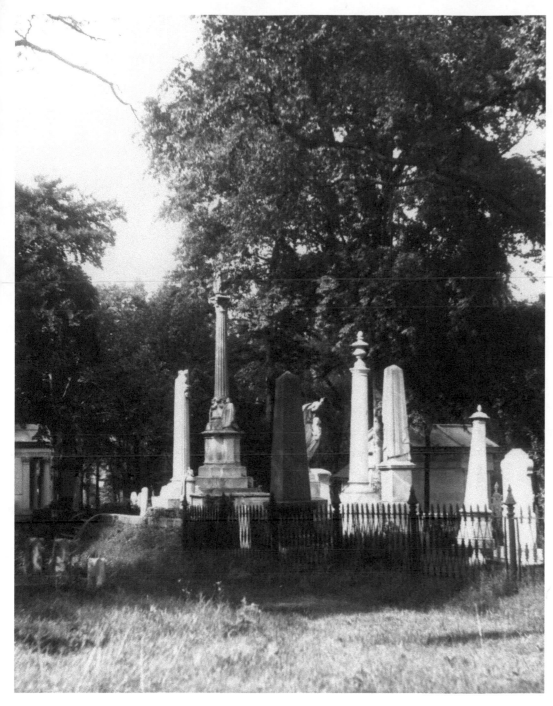

Mount Holly Cemetery is the most historically significant cemetery in Arkansas. It was established in 1843 and is the final resting place of many of Arkansas's early leaders, including 10 former governors, 6 United States senators, 14 Arkansas Supreme Court justices, 21 mayors of Little Rock, and many more historical figures. It is located at Broadway and Twelfth Street.

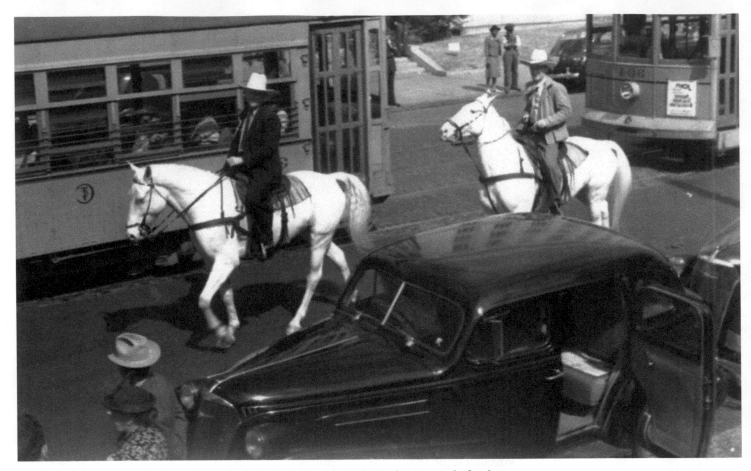

Members of the El Dorado delegation ride through downtown Little Rock in a parade for the Arkansas State Livestock Show in 1940. El Dorado had become Arkansas's boomtown for discoveries of oil there in the 1920s and 1930s.

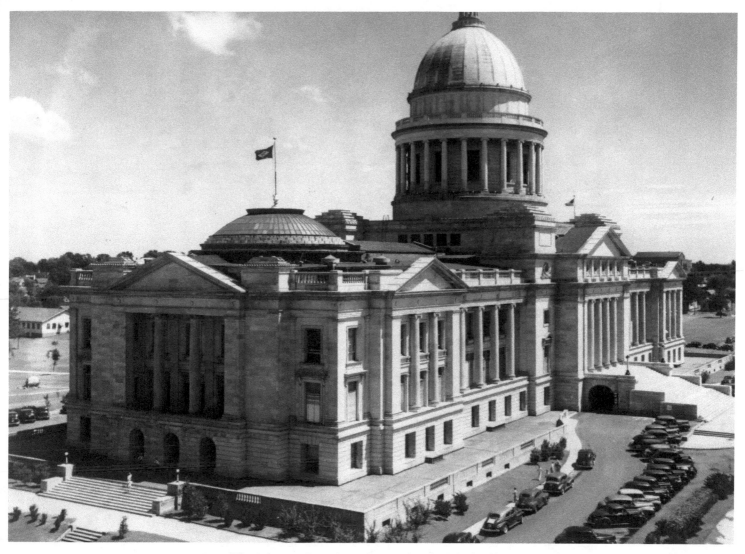

The Arkansas State Capitol around 1941. The building is a replica of the Capitol in Washington, D.C., and has appeared in many movies, including *Stone Cold* and *Under Siege*.

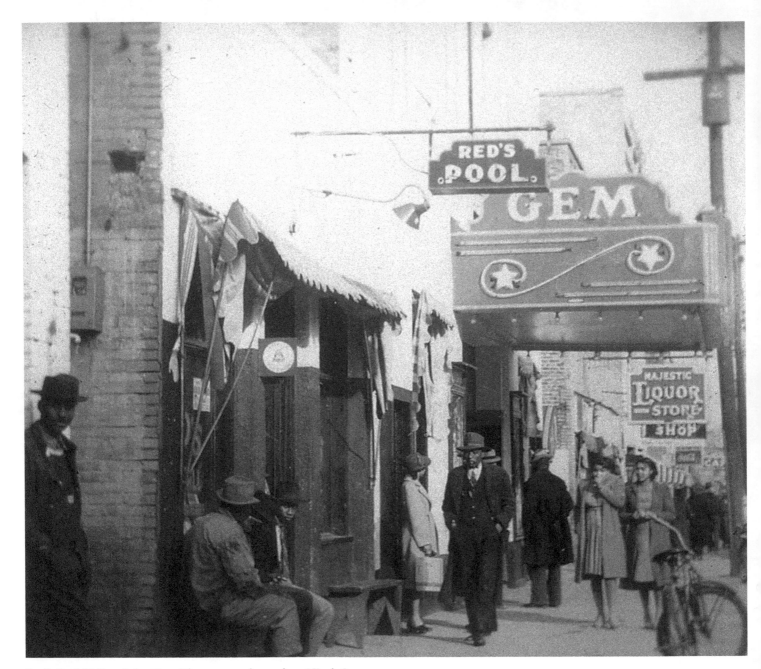

Red's Pool Hall and the Gem Theater were located on Ninth Street.

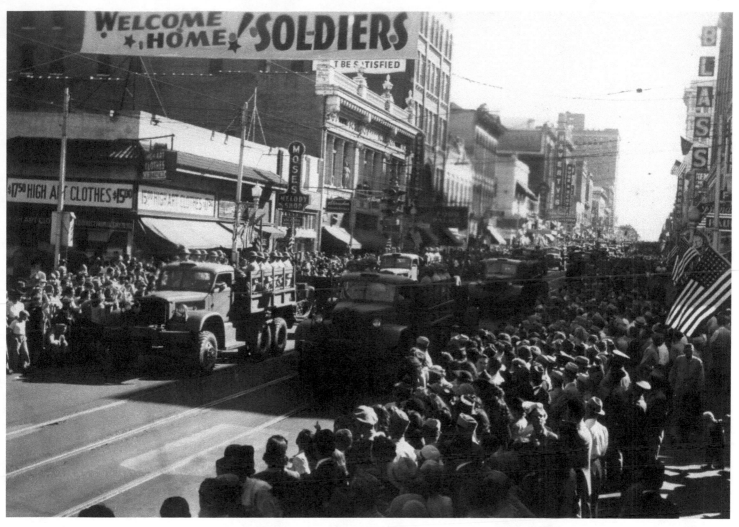

Locals gather for a parade in tribute to soldiers on the homefront, those riding the transport trucks in this image still wearing the helmetry designs of World War I. When Hitler and the Axis powers threatened the world with tyranny, the nation's armed forces headed overseas to fight a second world war.

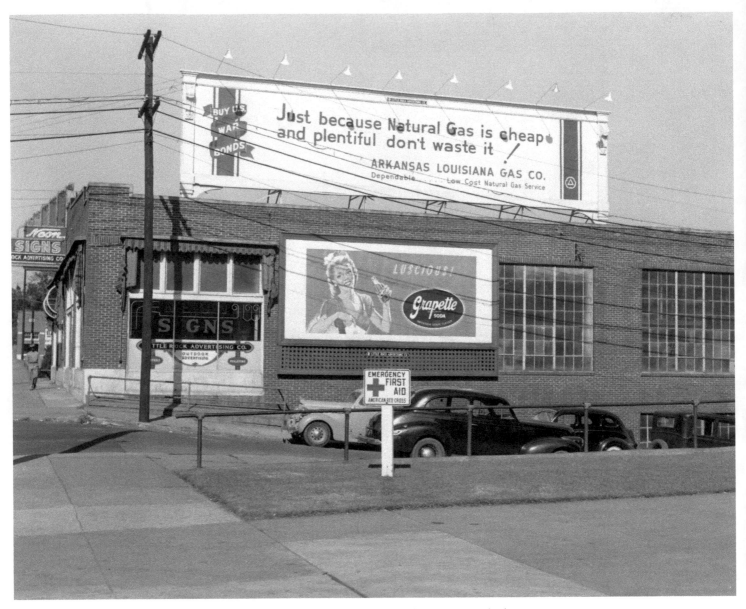

In 1942, this war-era billboard cautions citizens to conserve natural gas. Another gas, neon, had become fashionable for use in signage during the World War II era. Neon signs are being promoted by the Little Rock Advertising Company, in view here.

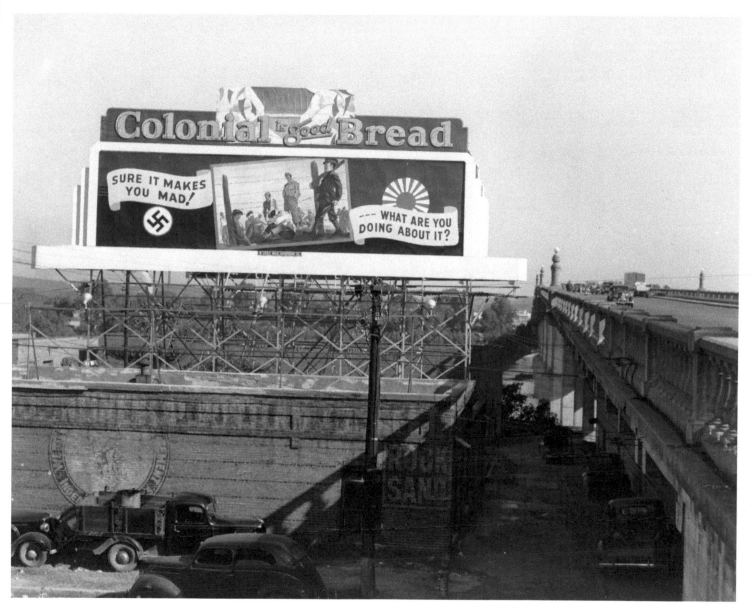

A billboard for Colonial Bread beside a bridge into Little Rock shows support for the Allies during World War II.

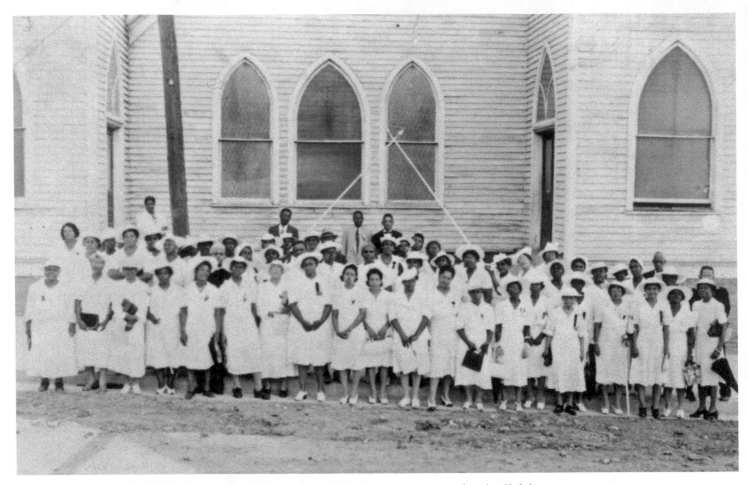

A group portrait outside Shiloh Baptist Church, located at 1200 Hanger Street, around 1942. Shiloh Baptist Church was established in 1888.

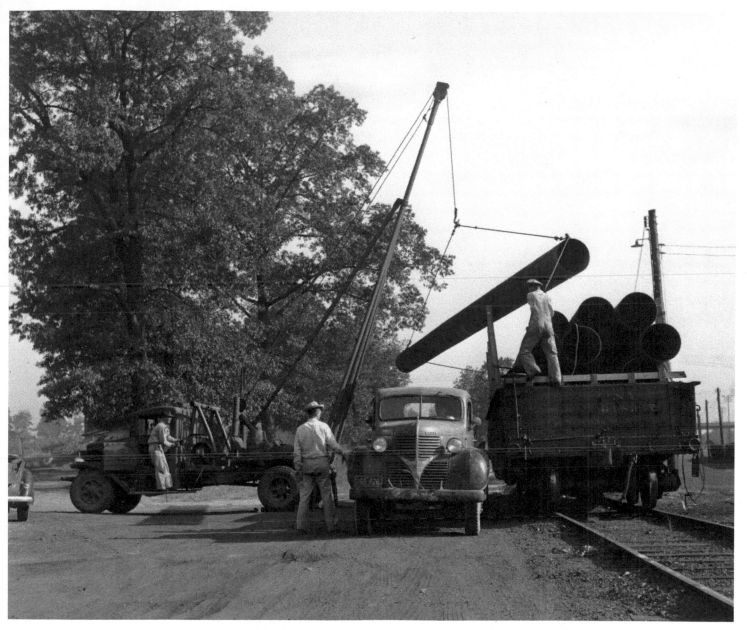

Three men load 40-foot sections of pipe onto stringing trucks in Little Rock in October 1942. The sections of pipe were part of a war emergency pipeline that ran from Longview, Texas, to Norris City, Illinois.

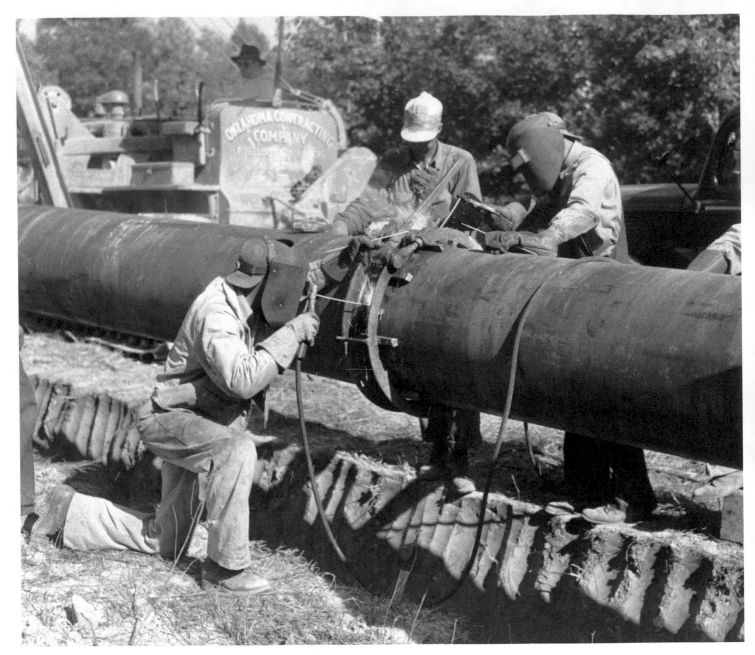

Construction workers weld sections of the gas pipe together.

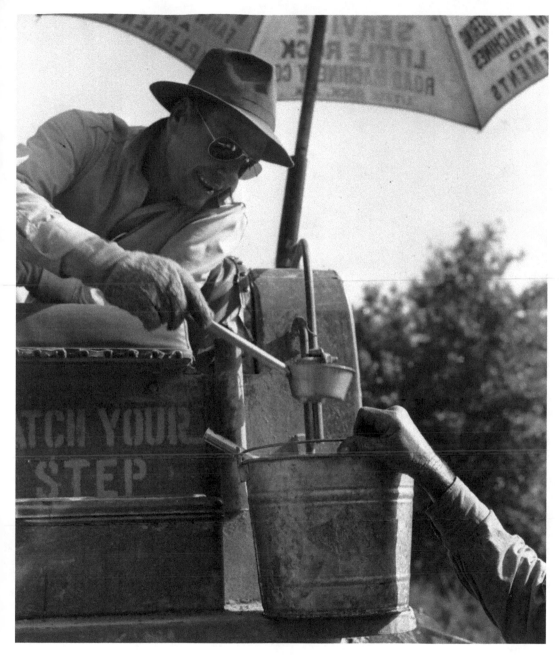

A heavy machinery operator working on the emergency pipeline takes a break and a sip of water.

Signage in front of City Hall in October 1942 promotes war bonds as a means of funding the construction of military aircraft. The United States had been engaged in the conflict overseas for nearly a year.

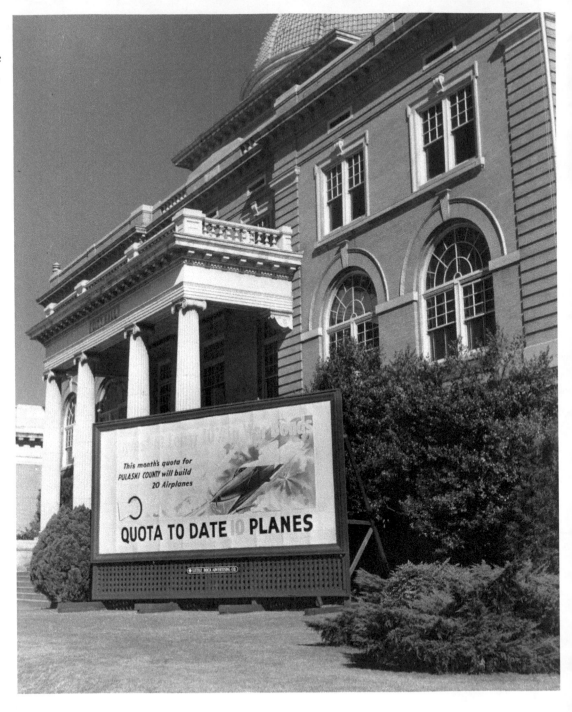

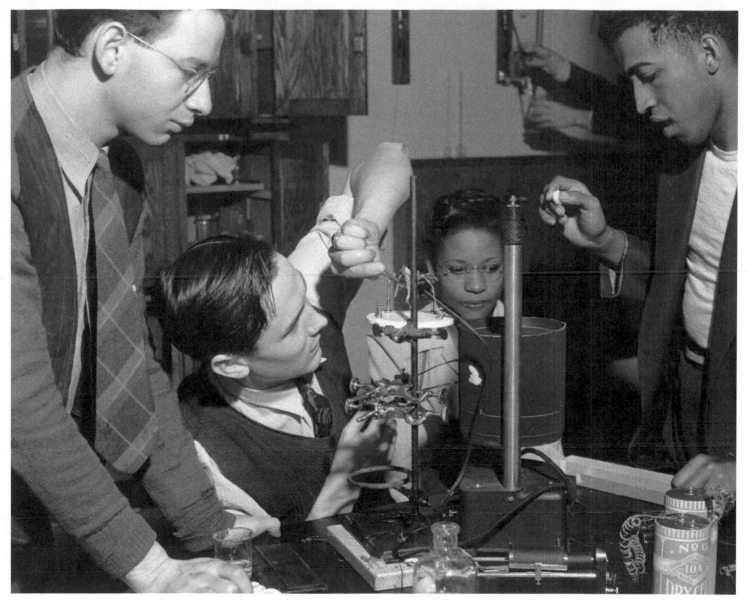

Postgraduate students perform an experiment to study the physiology of the muscle, around the 1940s. The experiment uses frog muscle tissue. Pictured are, left to right, J. S. Newcomer of the University of Utah; A. E. Bell of the University of Kentucky; Hiss Trondailer Jones of Lincoln University at Jefferson City, Missouri; and Samuel Massie of Arkansas State University.

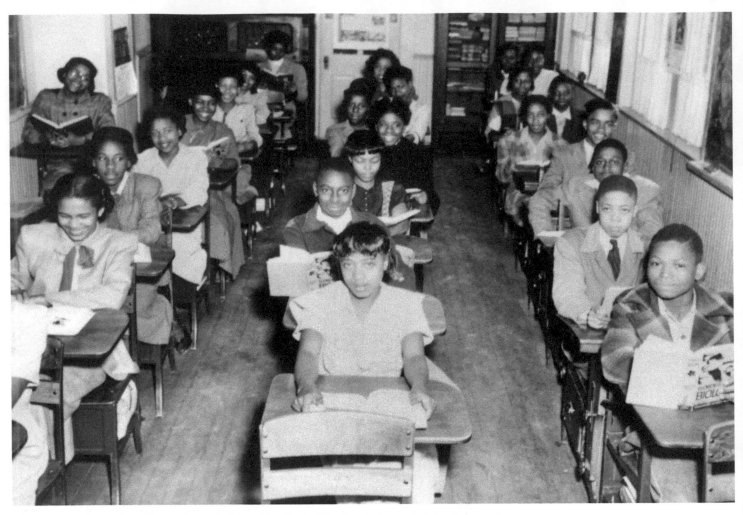

Class is in session at Saint Bartholomew's School in 1949. Saint Bartholomew's School, located at 1617 Marshall Street, was founded by Bishop John B. Morris in 1912 for African-American students. The school closed in 1976.

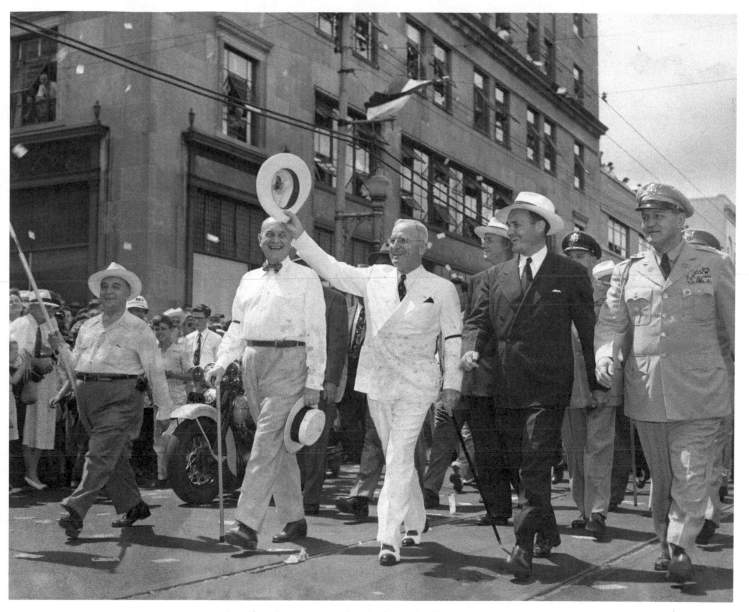

President Truman marches in the 35th Division Reunion parade on June 11, 1949. During World War I, as commander of Battery D, 129th Field Artillery regiment, 35th Division, Truman earned the respect of his men by remaining calm and focused under fire. As president, he made the decision to drop the atomic bomb on the Japanese cities of Hiroshima and Nagasaki, ending World War II.

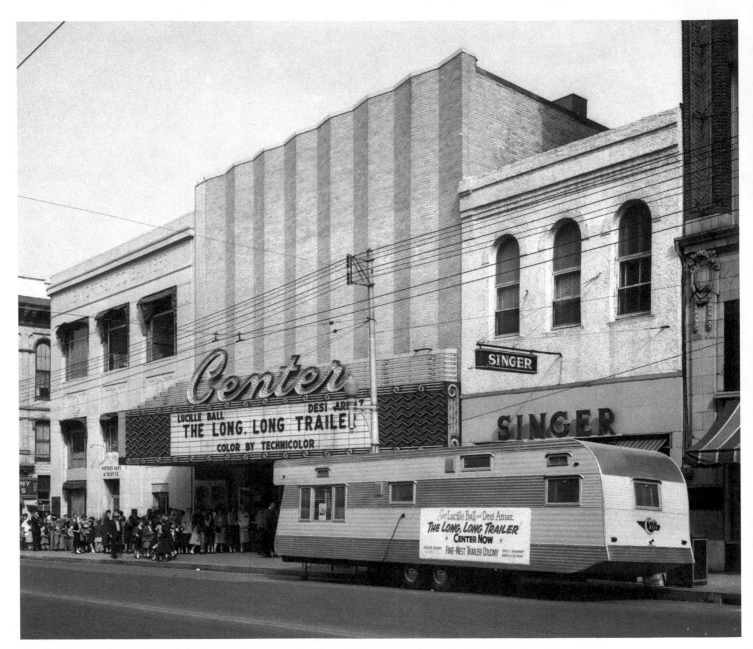

Flanked by Worthen Bank and the Singer Company, the Center Theater was located at East Fourth and Main streets. Little Rockers are queuing up here to see Lucille Ball and Desi Arnaz in the 1954 comedy *The Long, Long Trailer,* about the misadventures of a couple crossing the country to see the sights.

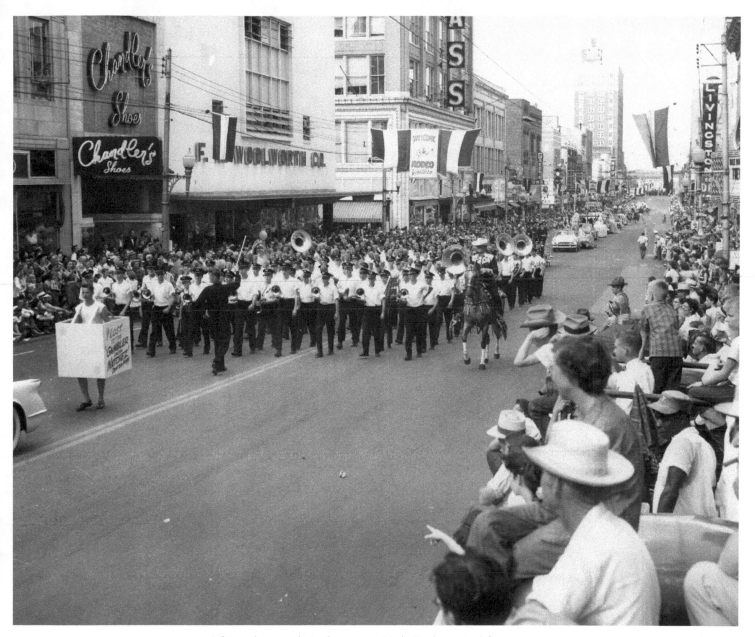

This rodeo parade in downtown Little Rock in 1954 features a man wearing a box sign. The ploy was an ad for *The Gambler from Natchez,* then showing at the Center Theater.

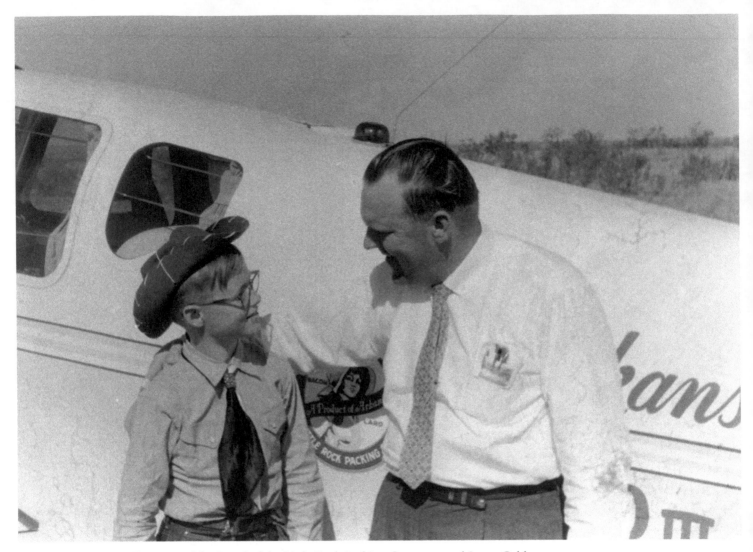

Chris E. Finkbeiner, Chairman of the Board of the Little Rock Packing Company, and James Cobler of Hot Springs, stand in front of Finkbeiner's private plane in June 1956. The two were traveling to the Boy's Ranch in Tascosa, Texas.

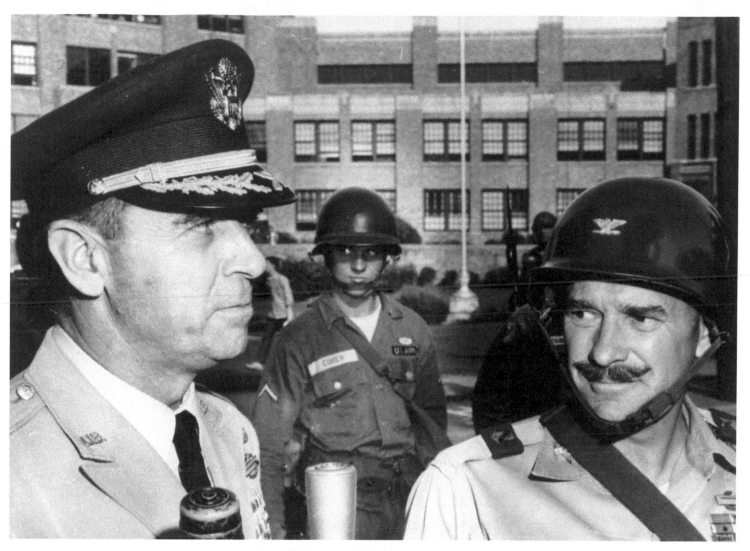

Major General Edwin A. Walker (left) stands with Colonel William A. Kuhn of the 327th Airborne Battle Group outside Central High School on September 25, 1957. The two officers were enforcing integration of the school.

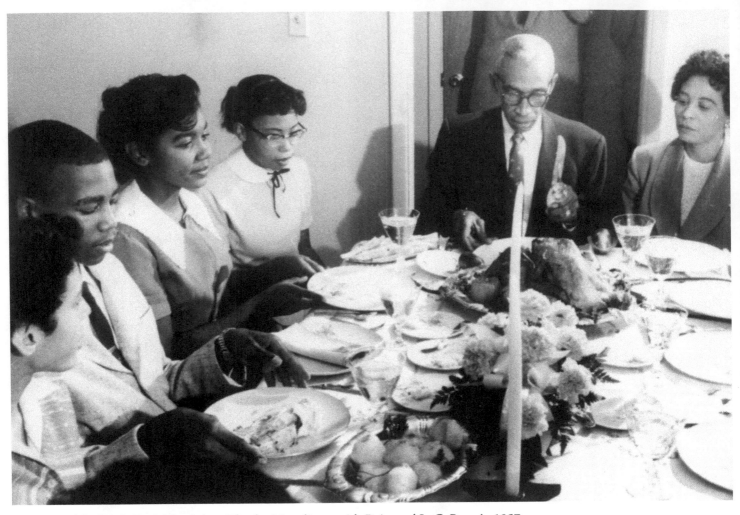

Members of the "Little Rock Nine" share Thanksgiving dinner with Daisy and L. C. Bates in 1957. Pictured left to right are Carlotta Walls, Terrence Roberts, Melba Pattillo, Thelma Mothershed, L. C. Bates, and Daisy Bates.

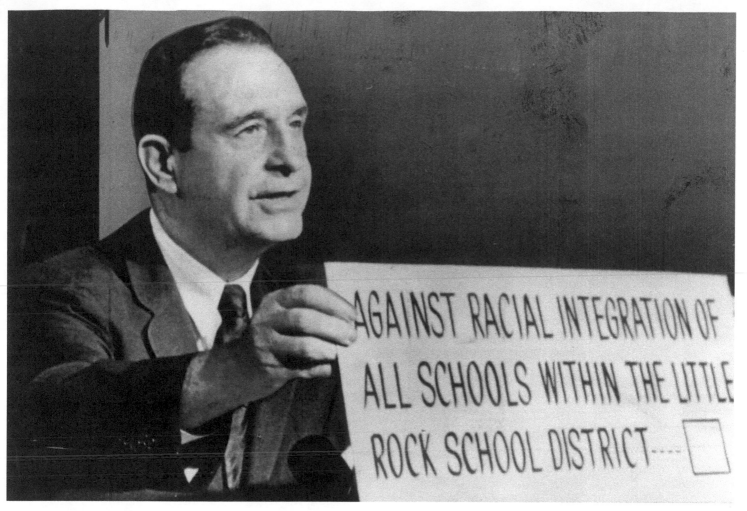

Despite the stance taken by Governor Faubus against desegregation of Little Rock's public schools, he was elected to six terms as governor, receiving 81 percent of the black vote in his 1964 bid against Republican challenger Winthrop Rockefeller.

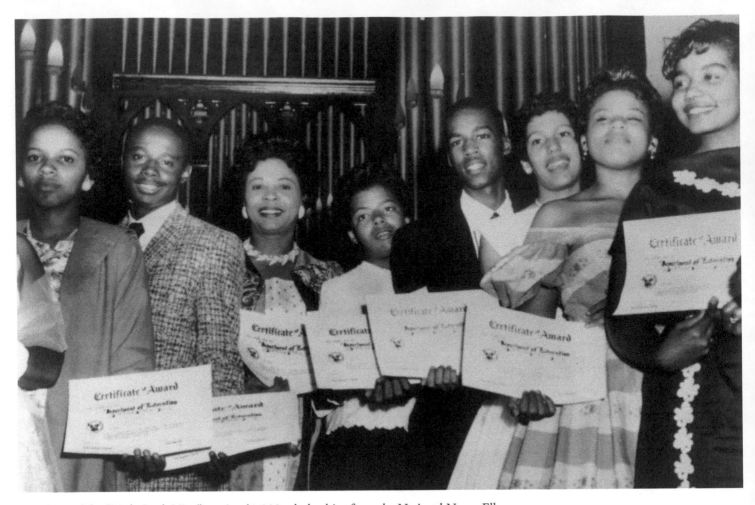

Members of the "Little Rock Nine" receive $1,000 scholarships from the National Negro Elks Convention in 1958. In view left to right are Gloria Ray, Jefferson Thomas, Daisy Bates, Elizabeth Eckford, Terrence Roberts, Carlotta Walls, Minnijean Brown, and Melba Pattillo.

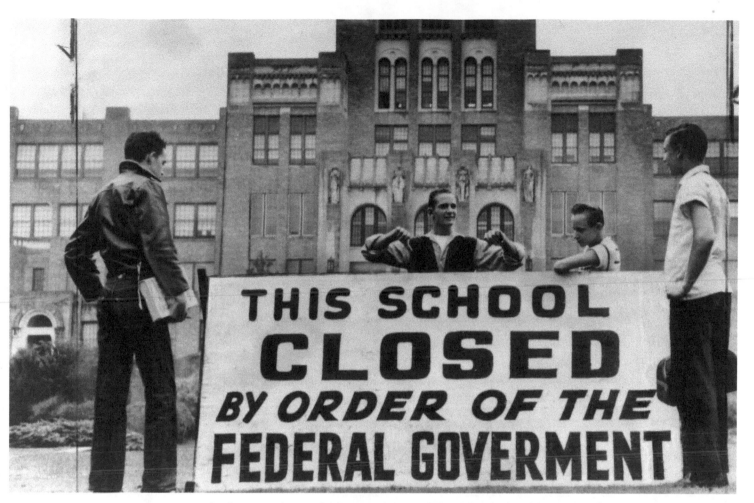

Students stand around a sign proclaiming "This School Closed by Order of the Federal Government" in front of Central High School in 1958. To outmaneuver Faubus, President Eisenhower would federalize the Arkansas National Guard, thus removing them from the governor's control.

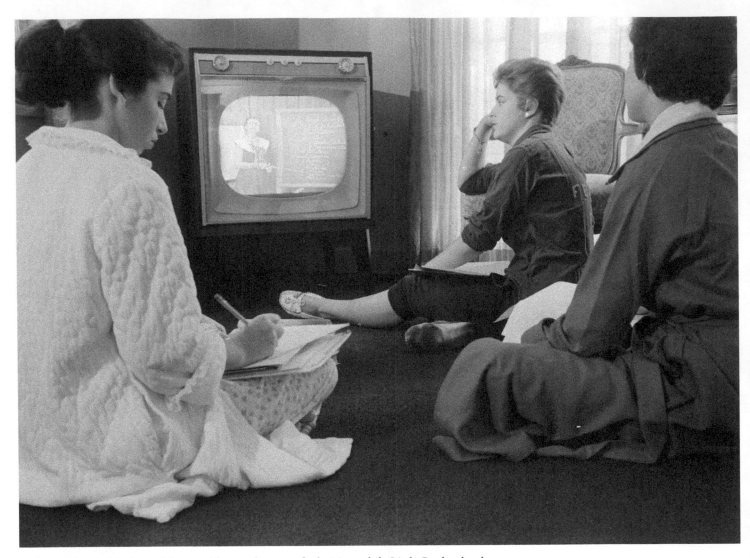

In September 1958, three girls attend lessons by way of television while Little Rock schools were closed. Public schools did not reopen until August 1959, and the intervening year became known as the "Lost Year."

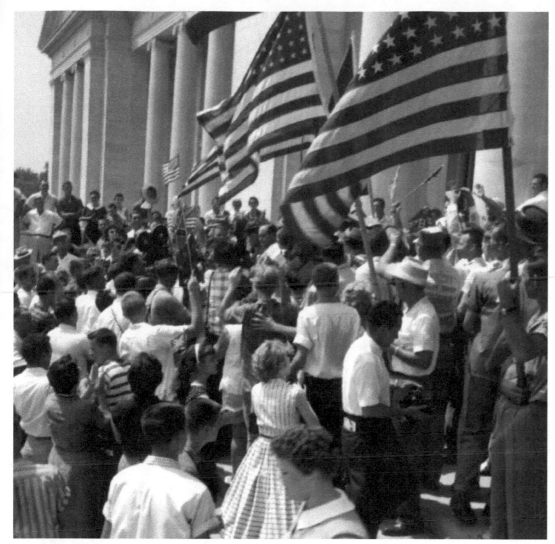

A group of protesters gather on the front steps of the Arkansas state capitol on August 20, 1959, to protest the integration of Central High School.

Two citizens stand in front of the Arkansas state capitol to protest the integration of the state's high schools in 1959.

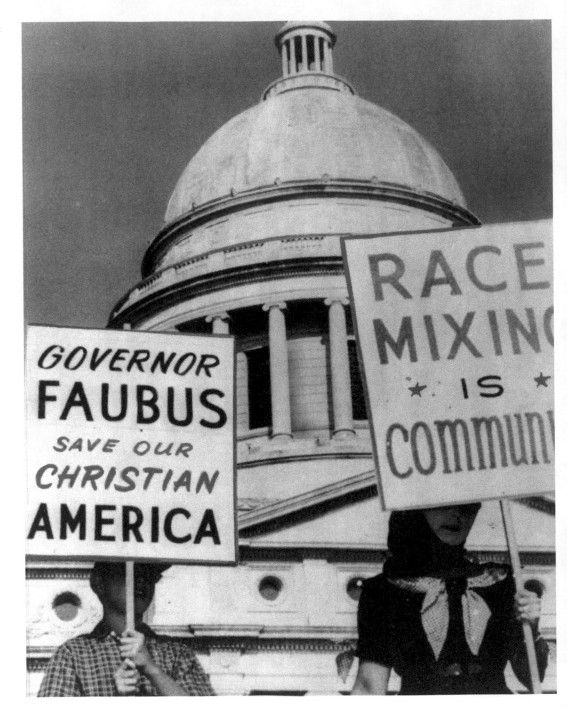

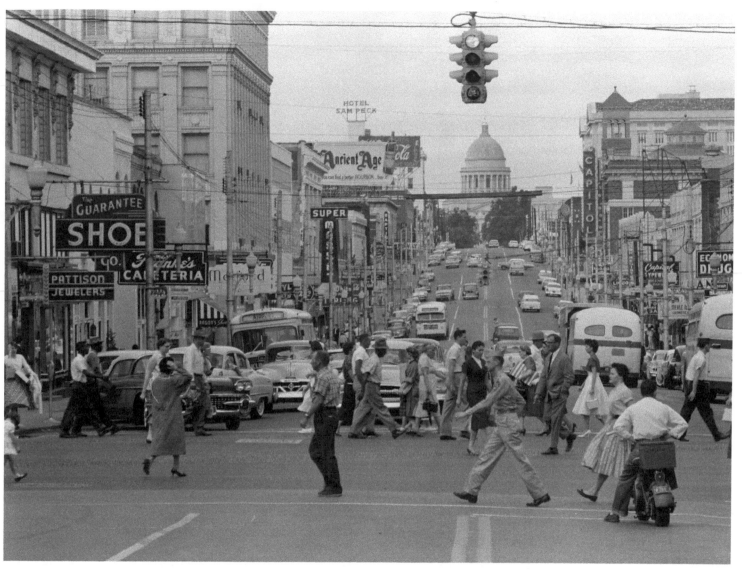

September 17, 1958, was a typical day on Capitol Avenue in downtown Little Rock.

Mary Alice Pickens and Floy Jeanne Cash check new arrivals to the Little Rock Library in February 1958. The Little Rock Library Commission mailed books to people throughout the state of Arkansas. The primary recipients were those with no access to libraries or bookmobiles.

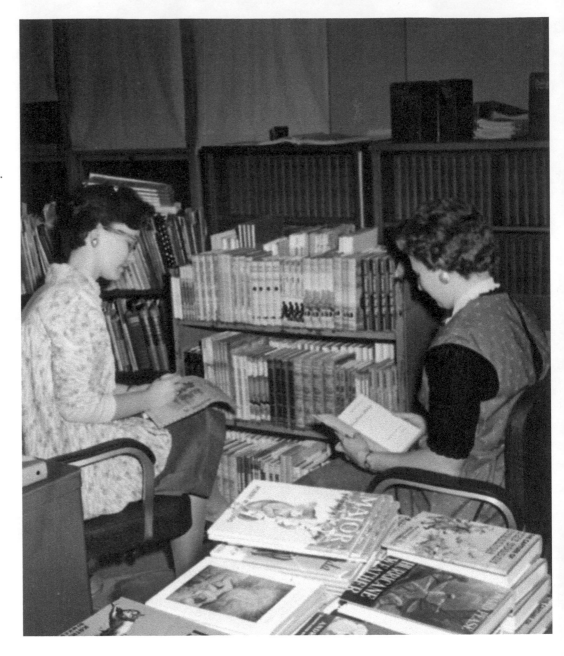

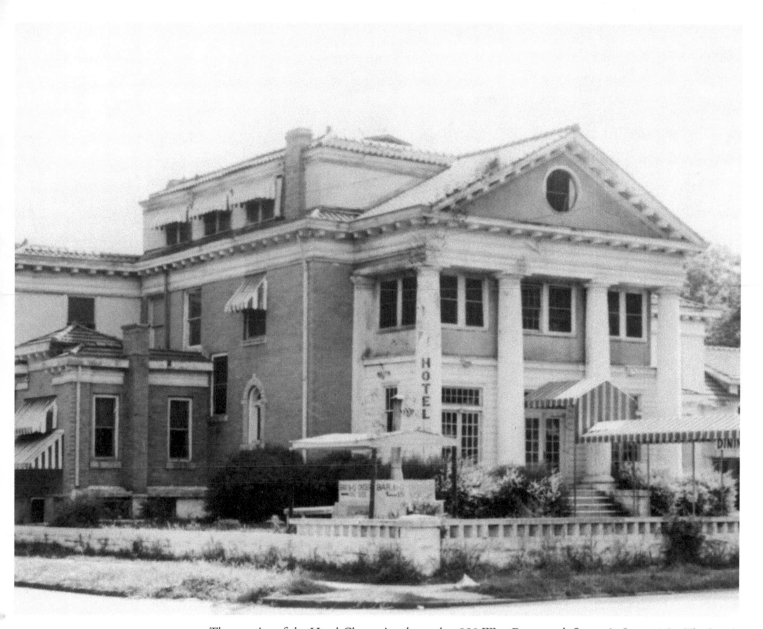

The exterior of the Hotel Charmaine, located at 820 West Fourteenth Street, in June 1961. The hotel, originally a hospital, was purchased by H. L. Johnson in 1949 and remodeled, becoming Little Rock's leading African-American hotel and hosting celebrities like Jackie Robinson and Fats Domino. The hotel was razed the same year this image was recorded to make way for the expansion of Philander Smith College.

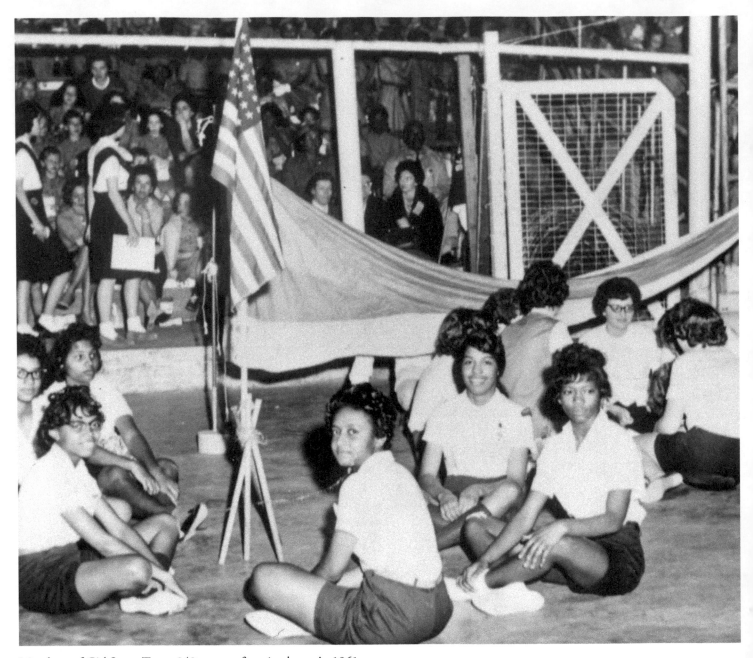

Members of Girl Scout Troop 248 prepare for a jamboree in 1961.

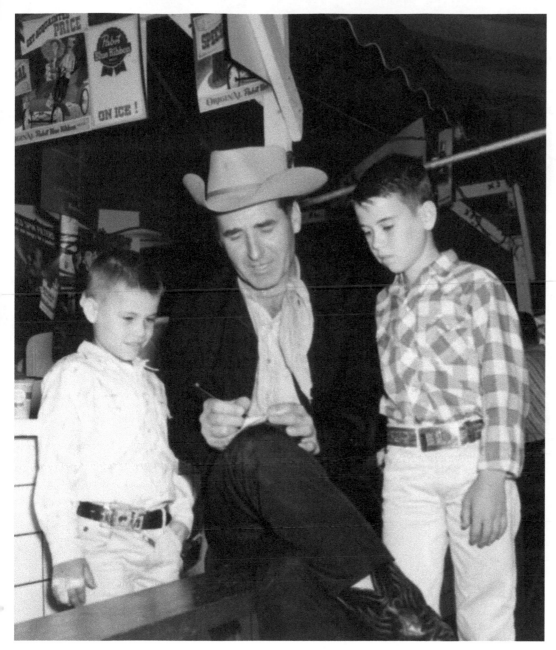

Sheb Wooley, a star from the TV show *Rawhide,* signs autographs for two youngsters in front of Barton Coliseum at the Arkansas Livestock Show in October 1962. Wooley also wrote the hit song "Purple People Eater," wrote the theme song for the TV show *Hee Haw,* and acted in western movies including the classic *High Noon.*

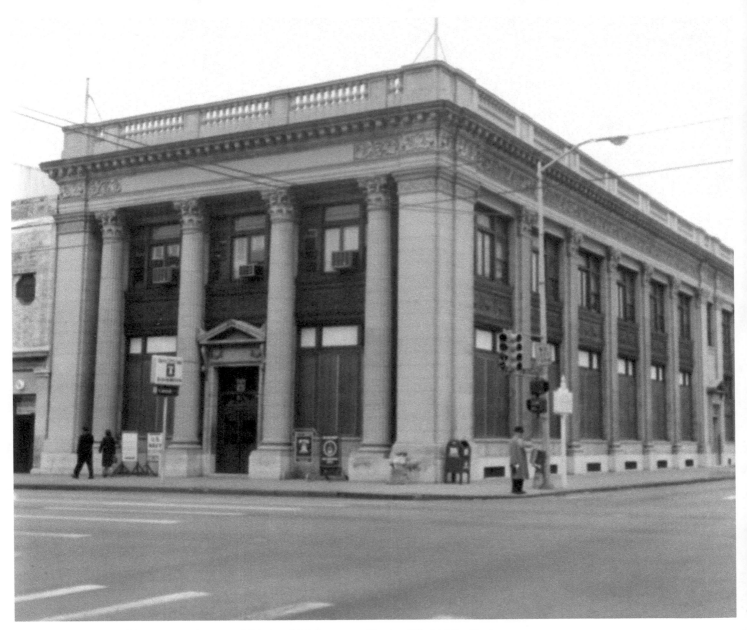

The World War II Soldier Service Center at Third and Main streets. During World War II, the building housed recreational services for thousands of soldiers and their families. By February 1964, it was serving as a recruiting headquarters for all four branches of the American military.

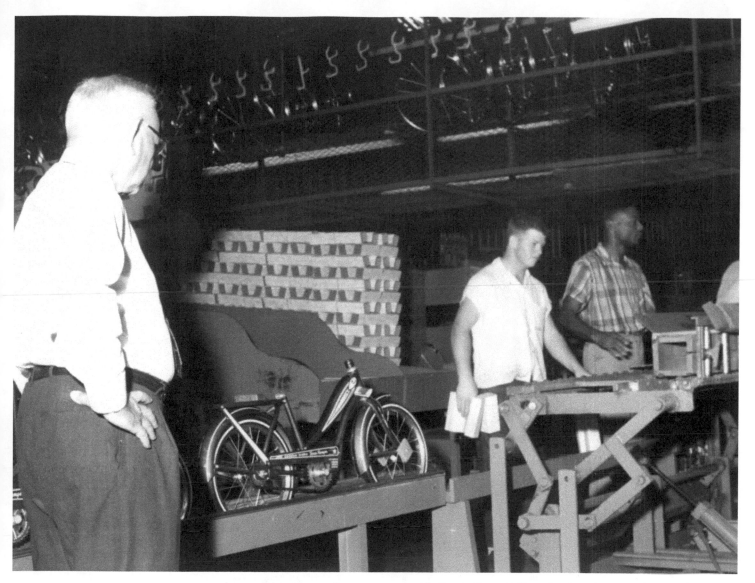

A man supervises workers on an assembly line in June 1963 at the American Machine and Foundry Bicycle Factory, located at West 65th and Patterson streets.

Louisiana Street at night in 1960.

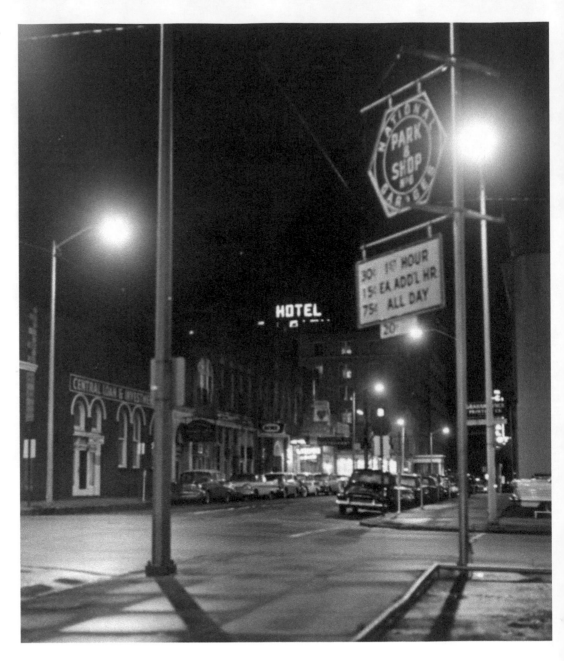

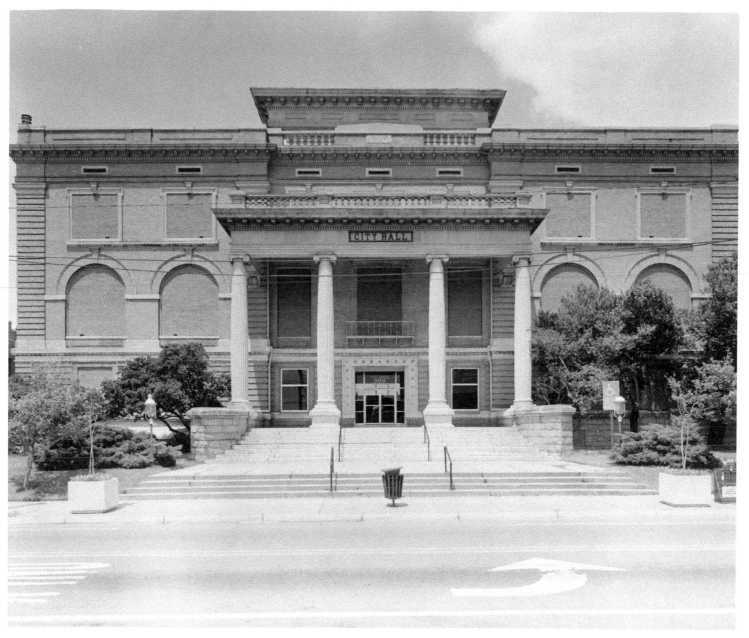

Little Rock City Hall as it appeared in the more recent past.

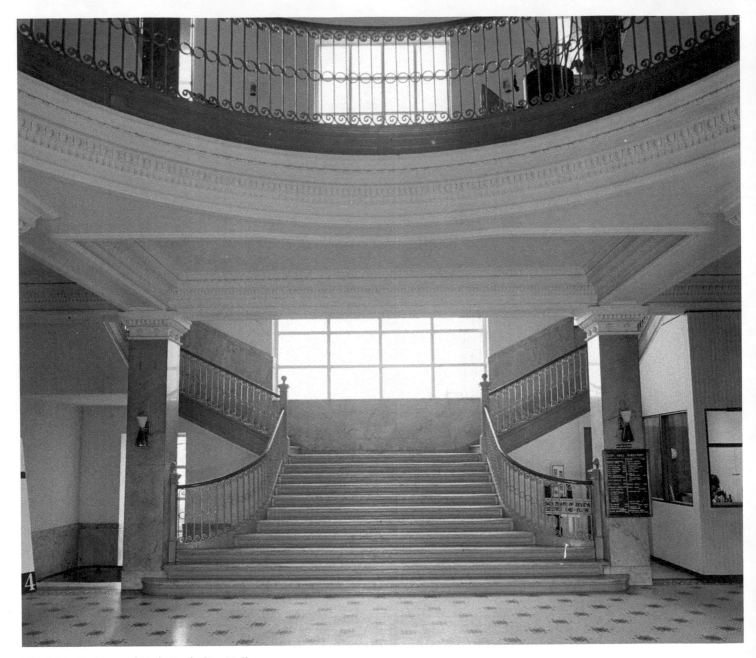

The Main Staircase of Little Rock City Hall.

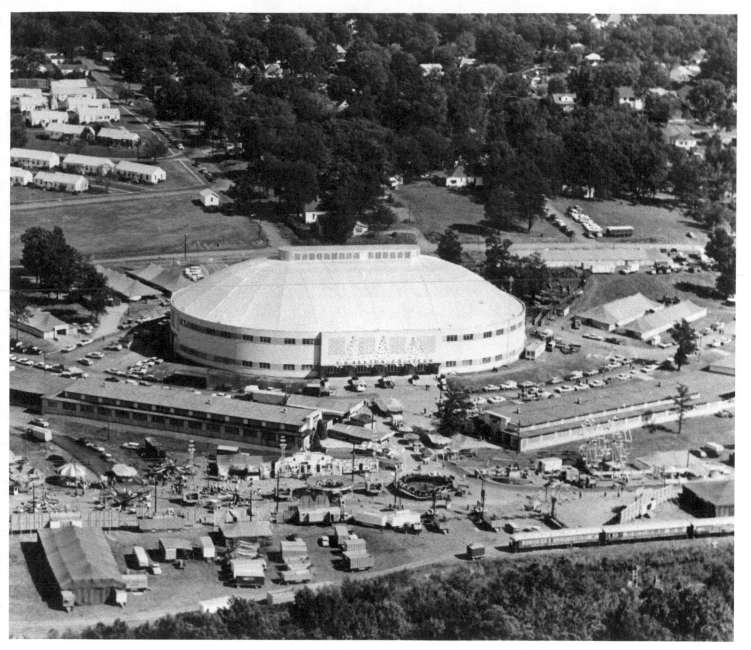

An aerial view of Barton Coliseum, a 7,150-seat multi-purpose auditorium located on the State Fair grounds.

The Old State House in August 1967. The structure was aging gracefully.

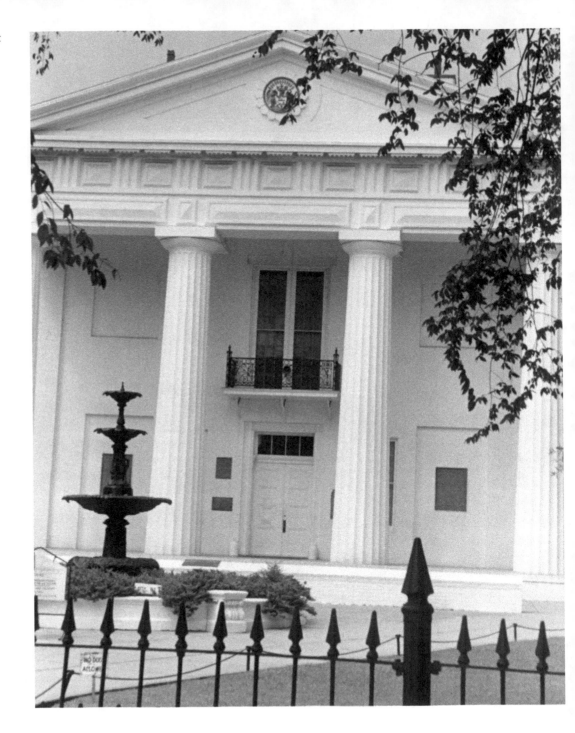

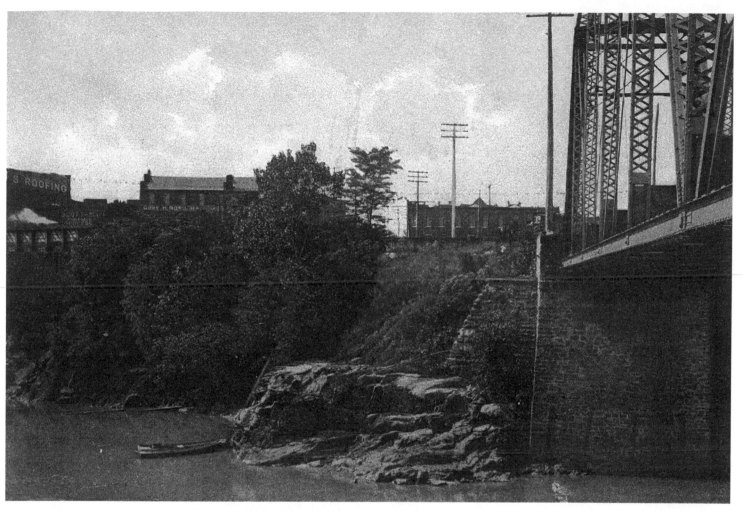

"La Petite Roche," for which the city was named, was discovered by Jean-Baptiste Benard de la Harpe in 1772. The rock was partially destroyed in the early 1900s during the construction of a railroad bridge. During the 1980s, the rock was cleaned and preserved as part of a riverfront redevelopment plan.

Notes on the Photographs

These notes, listed by page number, attempt to include all aspects known of the photographs. Each of the photographs is identified by the page number, a title or description, photographer and collection, archive, and call or box number when applicable. Although every attempt was made to collect all data, in some cases complete data may have been unavailable due to the age and condition of some of the photographs and records.

COVER IMAGE:
Library of Congress
6a17383u

II **WEST ON MARKHAM STREET**
University of Arkansas
UALR Photo Coll. 79.AR.57

VI **BIG ROCK MOUNTAIN**
Courtesy, Arkansas History
Commission
G1730

X **MAIN AND MARKHAM, 1863**
University of Arkansas
UALR Photo Coll. 79.AR.40

2 **ARKANSAS RIVER RAILWAY BRIDGE**
Courtesy, Arkansas History
Commission
G2406

3 **TORRENT FIRE COMPANY**
University of Arkansas
UALR Photo Coll. 10.020

4 **BOWMAN BLOCK**
University of Arkansas
UALR Photo Coll. 37.005

5 **MULE-POWERED STREETCARS, 1877**
Courtesy, Arkansas History
Commission
G1895

6 **FROZEN ARKANSAS RIVER, 1876**
Courtesy, Arkansas History
Commission
G1704-2

7 **DENCKLA BLOCK**
Courtesy, Arkansas History
Commission
G1853

8 **McALMONT AND GIBSON DRUGSTORE**
Courtesy, Arkansas History
Commission
G1780

9 **ARKANSAS DEAF MUTE INSTITUTE**
Courtesy, Arkansas History
Commission
G1916-02

10 **LITTLE ROCK CATHOLIC CHURCH**
Courtesy, Arkansas History
Commission
G1701

11 **ARKANSAS RIVER RIVERBANKS**
Courtesy, Arkansas History
Commission
G1769-02

12 **PINEY POINT, 1880**
Courtesy, Arkansas History
Commission
G1872

13 **MOUNT ST. MARY'S ACADEMY**
University of Arkansas
UALR Photo Coll. 67.114

14 **MILTON RICE HOUSE**
Courtesy, Arkansas History
Commission
G2976-50B

15 **FIRST CHRISTIAN CHURCH**
Butler Center for Arkansas
Studies
PHO 2-A-12-17 Box 3

16 **HOTEL RICHELIEU**
University of Arkansas
UALR Photo Coll. 37.002

17 **METROPOLITAN HOTEL, 1870s**
Courtesy, Arkansas History
Commission
G2490

18 **POST OFFICE AND COURTHOUSE**
Butler Center for Arkansas
Studies
PHO 2-A-6-51 Box 1

19 **MASONIC TEMPLE**
Butler Center for Arkansas
Studies
PHO 2-A-6-83 Box 2

20 **FIRST GERMAN EVANGELICAL LUTHERAN CHURCH**
Butler Center for Arkansas
Studies
PHO 2-A-12-44 Box 1

21 **STEAMBOAT CHOCTAW**
Courtesy, Arkansas History
Commission
ECD2190

22 **LITTLE ROCK AND MEMPHIS RAILROAD COMPANY**
Butler Center for Arkansas Studies
PHO 2-A-20-112 Box 3

23 **B. HEINE CONFECTIONERY**
Butler Center for Arkansas Studies
PHO 2-A-10-64 Box 3

24 **PULASKI COUNTY COURTHOUSE**
Library of Congress
LC-USZ62-59893

26 **POST OFFICE AND COURTHOUSE**
Courtesy, Arkansas History Commission
ECD1807-09

27 **JOHN JACOBS AND FARM**
University of Arkansas
UALR Photo Coll. 37.89

28 **W. SIDERS WITH RIG**
Courtesy, Arkansas History Commission
PS67

29 **CEREMONY AT ST. EDWARD'S**
Butler Center for Arkansas Studies
PHO 2-A-12-93 Box 4

30 **VIEW OF MAIN STREET**
Library of Congress
LC-D4-71727

31 **VIEW OF MAIN STREET NO. 2**
Library of Congress
LC-D4-39505

32 **BEAR PITS IN FOREST PARK**
Library of Congress
LC-D4-39506

33 **CITY PARK MEMORIAL FOUNTAIN**
Library of Congress
LC-D4-71738

34 **LITTLE ROCK TRAVELERS BASEBALL TEAM**
Butler Center for Arkansas Studies
PHO 2-A-16-38 Box 3

35 **CITY STABLES**
Butler Center for Arkansas Studies
PHO 2-A-20-124 Box 3

36 **THE POST OFFICE, 1910**
Library of Congress
LC-D4-39508

37 **FOREST PARK THEATER**
Library of Congress
LC-D4-39507

38 **VIEW OF MAIN STREET NO. 3**
Butler Center for Arkansas Studies
PHO 2-A-7-16 Box 1

39 **LITTLE ROCK HIGH SCHOOL**
Library of Congress
LC-D4-71745

40 **CITY HALL**
Library of Congress
LC-D4-71743

41 **THE FRED KRAMER SCHOOL**
Butler Center for Arkansas Studies
PHO 2-A-5-1 Box 1

42 **VISIT BY THEODORE ROOSEVELT**
Butler Center for Arkansas Studies
PHO 2-A-18-47 Box 2

43 **UNIVERSITY OF ARKANSAS MEDICAL SCHOOL CLASS PORTRAIT, 1908**
Butler Center for Arkansas Studies
PHO 2-A-23-46 Box 1

44 **FIELD TRIP TO PULASKI HEIGHTS**
Butler Center for Arkansas Studies
PHO 2-A-5-67 Box 1

45 **MOUNT ST. MARY'S ACADEMY 1909 BASKETBALL TEAM**
Butler Center for Arkansas Studies
PHO 2-A-12-100 Box 4

46 **STATE CAPITOL CONSTRUCTION, 1910**
Butler Center for Arkansas Studies
PHO 2-A-15-162 Box 4

47 **CONSTRUCTION OF CAPITOL DOME**
Butler Center for Arkansas Studies
PHO 2-A-15-161 Box 4

48 **EARLY 1900S STREET SCENE**
Courtesy, Arkansas History Commission
ECD1807-23

49 **GEORGE REICHARDT HOUSE**
Butler Center for Arkansas Studies
PHO 2-A-6-243 Box 4

50 **C. J. KRAMER AND COMPANY INTERIOR**
Butler Center for Arkansas Studies
PHO 2-A-10-120 Box 4

51 **PANORAMA OF THE CITY**
Library of Congress
6a17392u

52 **CHAPPLE GROCERY DELIVERY RIG**
Courtesy, Arkansas History Commission
PS36-02

53 **DINING CAR INTERIOR**
Courtesy, Arkansas History Commission
GO204-18

54 **ARIZONA HOT-AIR BALLOON**
Courtesy, Arkansas History Commission
G2678-01

55 **CITY PARK MONUMENT-UNVEILING CEREMONY**
Courtesy, Arkansas History Commission
G5178-09

56 **CONFEDERATE VETERANS' REUNION**
Courtesy, Arkansas History Commission
G2678-11

57 **CONFEDERATE VETERANS' REUNION NO. 2**
Courtesy, Arkansas History Commission
G2678-05

58 **CONFEDERATE VETERANS' REUNION NO. 3**
Courtesy, Arkansas History Commission
G5178-30

59 **CONFEDERATE VETERANS' REUNION NO. 4**
Courtesy, Arkansas History Commission
G5178-22

60 **CITY PARK BARRACKS CANNON**
Library of Congress
LC-D4-71739

61 **WEST SECOND STREET EARLY 1900S**
Library of Congress
LC-D4-71729

62 **LITTLE ROCK CARNEGIE LIBRARY**
Library of Congress
LC-D4-71740

63 **SECOND BAPTIST CHURCH**
Library of Congress
LC-D4-71737

64 **LAYING STREETCAR TRACK**
Courtesy, Arkansas History Commission
PS19-2

65 **THE FREE BRIDGE**
Library of Congress
LC-D4-71732

66 **THE CAPITAL HOTEL**
Library of Congress
LC-D4-71734

67 **LITTLE ROCK POLICE PATROL**
Butler Center for Arkansas Studies
PHO 2-A-21-7 Box 2

68 **HOTEL MARION**
Library of Congress
LC-D4-71735

69 **AERIAL VIEW, 1918**
Courtesy, Arkansas History Commission
G4594-41

70 **NEW UNION DEPOT, 1921**
Library of Congress
LC-D4-71733

72 **DAVID O. DODD MEMORIAL**
Butler Center for Arkansas Studies
PHO 2-A-15-140 Box 3

73 **THE MCHENRY HOUSE**
Library of Congress
HABS ARK, 60-____, 1-1

74 **WALLACE BUILDING**
Butler Center for Arkansas Studies
PHO 2-A-6-99 Box 5

75 **FLOOD OF 1927**
Butler Center for Arkansas Studies
PHO 2-A-11-8 Box 1

76 **FLOODED STREET**
University of Arkansas
UALR Photo Coll. 8.035

77 **FLOOD OF 1927 AT BRIDGE**
Library of Congress
LC-USZ62-129438

78 **NEW BARING CROSS BRIDGE CONSTRUCTION**
Butler Center for Arkansas Studies
PHO 2-A-20-114 Box 3

79 **JAMLIN STAVE COMPANY OPERATIONS**
University of Arkansas
UALR Photo Coll. 29.006

80 **THE SHRINE TEMPLE**
University of Arkansas
UALR Photo Coll. 13.005

81 **OLD STATE HOUSE, 1934**
Library of Congress
HABS ARK, 60-LIRO,1-4

82 **CHECKING COTTON**
Library of Congress
LC-DIG-fsa-8a16149

83 **RED CROSS AND KLRA DROUGHT RELIEF EFFORT**
Library of Congress
LC-USZ62-101938

84 **SHARECROPPER FAMILY**
Library of Congress
LC-USF3301-006025-M3

85 **SHARECROPPER CHILDREN**
Library of Congress
LC-USF33-006026-M4

86 **HENDERLITER PLACE, 1934**
Library of Congress
HABS ARK, 60-LIRO,2-1

87 **TYPICAL OCTOBER SUNDAY**
Library of Congress
LC-USF3301-006025-M5

88 **UNITED STATES ARSENAL**
Library of Congress
HABS ARK,60-LIRO,3-1

89 **TRAPNALL HALL**
Library of Congress
HABS ARK,60-LIRO,4-1

90 **SOFT DRINK SUMMIT**
Library of Congress
LC-USF34-0182590-C

92 **PIKE-FLETCHER-TERRY HOUSE**
Library of Congress
HABS ARK,60-LIRO,5-1

93 **MOUNT HOLLY CEMETERY**
Butler Center for Arkansas Studies
PHO 2-A-22-40 Box 1

94 **EL DORADO DELEGATION**
Courtesy, Arkansas History Commission
ECD1585-3

95 **STATE CAPITOL, 1941**
Library of Congress
LC-USZ62-59643

96 **RED'S POOL HALL AND GEM THEATER**
Butler Center for Arkansas Studies
PHO 2-A-4-116 Box 3

97 **WORLD WAR II PARADE**
Butler Center for Arkansas Studies
PHO 2-A-18-104A Box 1

98 **SIGNS OF THE TIMES**
Library of Congress
LC-USW3-009375-D

99 **WORLD WAR II BILLBOARD**
Library of Congress
LC-USW3-009431-D

100 **SHILOH BAPTIST CHURCH GROUP SHOT**
Courtesy, Arkansas History Commission
PS13-03

101 **EMERGENCY GAS PIPE**
Library of Congress
LC-USW3-009308-D

102 **WELDING SECTIONS OF THE PIPELINE**
Library of Congress
LC-USW3-009247-D

103 PIPELINE CREWMAN ON BREAK
Library of Congress
LC-USW3-009253-D

104 CITY HALL SIGNAGE
Library of Congress
LC-USW3-009432-D

105 POSTGRADUATE EXPERIMENT
Library of Congress
LC-USW3-002671-D

106 SAINT BARTHOLOMEW'S CLASS
Courtesy, Arkansas History Commission
PS51-29

107 PRESIDENT TRUMAN IN PARADE
Butler Center for Arkansas Studies
PHO 2-A-18-101 Box 3

108 THE CENTER THEATER
University of Arkansas
UALR Photo Coll. 50.003

109 RODEO PARADE, 1954
University of Arkansas
UALR Photo Coll. 50.008

110 CHRIS FINKBEINER AND JAMES COBLER
Courtesy, Arkansas History Commission
ECD0217-8

111 ENFORCING INTEGRATION
Library of Congress
LC-USZ62-135290

112 LITTLE ROCK NINE AT THANKSGIVING DINNER
Courtesy, Arkansas History Commission
G1775-12

113 OPPOSING INTEGRATION
Library of Congress
LC-USZ62-126829

114 SCHOLARSHIPS FOR THE LITTLE ROCK NINE
Library of Congress
LC-USZ62-126833

115 SCHOOL CLOSING
Library of Congress
LC-USZ62-126828

116 LESSONS BY TV
Library of Congress
LC-U9-1525Q-35

117 PROTESTERS AT THE STATE CAPITOL
Courtesy, Arkansas History Commission
G1775-20

118 MORE PROTESTS
Library of Congress
LC-US62-127043

119 CAPITOL AVENUE, 1958
Library of Congress
LC-U9-1523A-26

120 AT THE LITTLE ROCK LIBRARY
Courtesy, Arkansas History Commission
ECD00694-04

121 HOTEL CHARMAINE BEFORE DEMOLITION
Courtesy, Arkansas History Commission
PS14-02

122 GIRL SCOUT TROOP 248
Courtesy, Arkansas History Commission
PS01-03

123 SHEB WOOLEY AND YOUNGSTERS
Courtesy, Arkansas History Commission
ECD1104-3

124 WORLD WAR II SOLDIER SERVICE CENTER
Courtesy, Arkansas History Commission
ECD0697

125 BICYCLE FACTORY OPERATION
Courtesy, Arkansas History Commission
ECD00008-8

126 LOUISIANA STREET AT NIGHT
Courtesy, Arkansas History Commission
ECD0714-1

127 CITY HALL IN RECENT PAST
Library of Congress
HABS ARK,60-LIRO,6-2

128 CITY HALL STAIRCASE
Library of Congress
HABS ARK,60-LIRO,6-5

129 AERIAL OF BARTON COLISEUM
Butler Center for Arkansas Studies
PHO 2-A-6-202 Box 5

130 OLD STATE HOUSE, 1967
Courtesy, Arkansas History Commission
ECD1530-4

131 LA PETITE ROCHE
University of Arkansas
UALR Photo Coll. 37.85

Printed in the USA
CPSIA information can be obtained
at www.ICGtesting.com
JSHW072025140824
68134JS00042B/3783

9 781683 368496